IMAGES
of America

HAVERFORD
TOWNSHIP

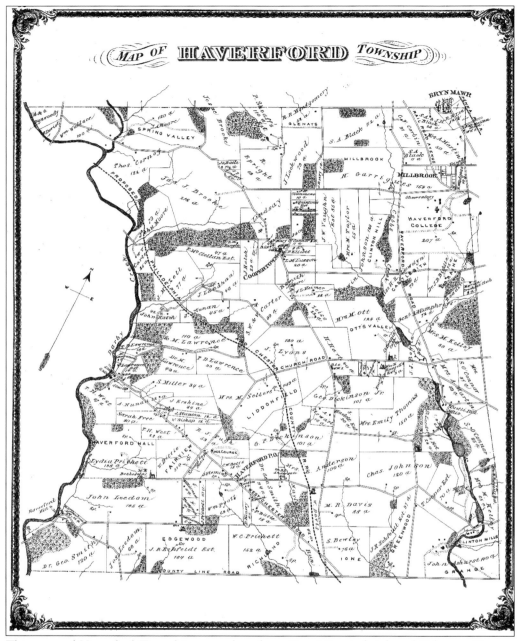

This map of Haverford Township was taken from *New Historical Atlas of Delaware County, Pennsylvania*, published by Everts & Stewart of Philadelphia in 1875.

IMAGES
of America

HAVERFORD
TOWNSHIP

Haverford Township Historical Society

ARCADIA
PUBLISHING

Published by Arcadia Publishing
Charleston, South Carolina

Printed in the United States of America

Library of Congress Catalog Card Number: 2003110236

For all general information contact Arcadia Publishing at:
Telephone 843-853-2070
Fax 843-853-0044
E-mail sales@arcadiapublishing.com
For customer service and orders:
Toll-Free 1-888-313-2665

Visit us on the Internet at www.arcadiapublishing.com

*To those who have preceded us in the task
of capturing and preserving history.*

CONTENTS

ABOUT THE PHOTOGRAPHS

Many of the images in this book came from the historical society's extensive collection. Generous neighbors as well as private and public institutions such as the Haverford Township Free Library, Sellers Library, Hagley Museum and Library, Philadelphia Jewish Archives Center, Thomas Massey House, and the Chester County Historical Society provided the rest. Every effort was taken to make this photographic history complete and attractive; however, some photographs could not be obtained despite our earnest attempts and persistence.

The earliest photographs contained in this book were taken by Dr. John W. Eckfeldt. A prominent physician in Philadelphia, Eckfeldt developed a passion for nature during his summer visits on his grandfather's farm, located on the land now known as Chatham Park and Llanerch. In 1917, he published the book entitled *Cobbs Creek in the Days of the Old Powder Mill.* This historical volume contains a wealth of knowledge and rare photographs of the black powder and cotton mills along the creek. The original photographs used in his book have been carefully preserved and maintained in the historical society's archives at Nitre Hall.

Another collection of photographs and glass slides deserves special mention. The photographer was Wilbur Hall, an engineer for the Philadelphia and Suburban Transit Company and longtime resident of Llanerch. Although many of the photographs, taken between 1900 and 1912, pertain to the railroad and trolley systems running through Haverford Township and were previously printed and published, dozens of the glass slides had never been seen by the public. These snapshots convey the pride and affection Hall held for both his family and community. We are indebted to Mrs. Richard Rosengarten, his daughter, for donating these photographs and slides to us.

Speaking for all the members of the pictorial history book committee, Donna Lunny, Betty Murta Graham, Renee Silver DeFiore, Mary Courtney, Carolyn Joseph, and myself, we are extremely proud and excited to present this body of work. Picture by picture, we discovered our community's history while meeting many wonderful and interesting people.

We hope you will find this book as exciting and enriching to read as it was for us to assemble.

Susan Facciolli
Committee Chairwoman

INTRODUCTION

Haverford Township, named for Haverfordshire or Haverford-West in Wales, was originally part of the Welsh Tract or Barony, including Radnor and Merion. Members of the Religious Society of Friends purchased 40,000 acres from William Penn and began arriving in 1682. These Friends, searching for religious freedom, self-government, and a place to speak their native language, found a wilderness forest out of which to carve their homesteads "upon ye West side of Skoolkill River." (William Penn, 1684.)

Haverford Township covers approximately 10 square miles, bordered on the west by the Darby Creek and our neighbor, Marple Township. Cobbs Creek, called Karakung by the Lenni Lenape and sometimes Mill Creek, nearly parallels the eastern border of the township with Lower Merion. Both streams were the sites of numerous grist- and sawmills, which combined with farming, formed the basis of local economy in the early days. Ithan Creek slices through the northwest corner of the township before joining Darby Creek. A fourth stream, Naylor's Run, nearly bisects the township and was the site of the early-20th-century Babies' Hospital. In the 19th century, the railroads, seeking to increase ridership, brought city dwellers to recreation sites along the Cobbs Creek and to new housing developments like Beechwood and Penfield, creating a rapid rise in population.

Today, to accommodate a population of more than 49,000 people, there are 165 miles of roads, three golf courses, convenient shopping centers, hundreds of acres of parks, a prestigious college, and even a bubble gum factory. Adults who were children here return to the safe haven of its tree-lined neighborhoods, where their own children attend the township's excellent schools. Parishes are strongly identified, and membership in civic associations and community groups continues to grow.

The Haverford Township Historical Society, founded in 1939 with a mission to preserve and promote interest in the history of the community, for years has desired to compile a general history of the township. Numerous resources, including primary sources, are available to the scholar-researcher, covering the nearly 325 years of Haverford Township history. For example, in the 19th century, Dr. George Smith and H.G. Ashmead each wrote histories of Delaware County, including the township's beginnings and early years. *The Historic Resources Survey*, published in 1994 by the Delaware County Planning Commission, provides an excellent resource for researching historic properties in Haverford Township. Scenic Powder Mill Valley is remembered by Dr. John W. Eckfeldt in his memoir *Cobbs Creek in the Days of the Old Powder Mill*, published in 1917. *A Graphic History of Delaware County*, printed by the Delaware County

Historical Society has detailed maps and timelines, and *A Survey of Mills in Delaware County, Pennsylvania, 1826–1880*, part of the Mills Project completed in 1994, details manufacturing in the Delaware Valley. In 1968, Edmund W. Viguers wrote a historical sketch of four farms in the southwest quadrant of the township called *Your Land and Mine*. Furthermore, any research into the American Revolution results in a learning opportunity about Haverford Township because of the proximity of its roads and mills to Philadelphia, the Brandywine Battlefield, and Washington's encampment at Valley Forge. Lectures provided by the Haverford Township Historical Society and courses given through the Haverford Township Adult School all add to this wealth of information.

Requests for copies of vintage photographs of the township inundate the historical society each year, and this volume may answer the frequently asked question "What did it look like back when?" Photograph posters of township sites catch the eye of shoppers at the Super Fresh store in Manoa Shopping Center and framed photographs of early times in the township fascinate patrons of Brookline Boulevard establishments. Commerce Bank on Eagle Road adorns its lobby with a large mural of Oakmont in the early 20th century. Antique photographs captivate our imagination, transport us to another time and inspire stewardship for our historic sites.

Included in this photographic history are important sites and references to notable people from the earliest days of Quaker settlement to the era of "towns within the township," the days when Bon Air, Brookline, Coopertown, Haverford, Llanerch, Manoa, Oakmont, and South Ardmore had distinct identities and mailing addresses. While not every photograph that could have been included will be found here, nor are they arranged in chronological order, every effort has been made to verify the information presented. The society is always pleased to receive well-documented new information about township history.

A note about the vagaries of spelling is perhaps appropriate at this point. In 1755, Samuel Johnson wrote his respected dictionary, and Noah Webster had published both a spelling book and dictionary by 1828; however, unlike today, when spelling is expected to be uniform, 18th-century and early-19th-century writers were less concerned with consistency. We have made a conscious effort to be true to original spelling wherever appropriate.

Images of our past found here of schools, fire companies, houses of worship, grand estates, and places of business and recreation will, perhaps, impart to the reader a sense of wonder at the changes that have indeed taken place and an appreciation for future historic preservation efforts in Haverford Township.

Mary Courtney

One

SETTLING IN

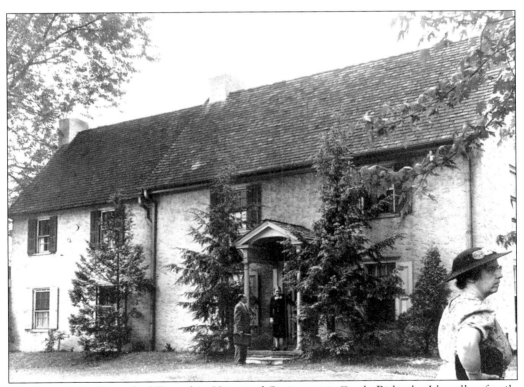

Members of the Haverford Township Historical Society visit Castle Bith, the Llewellyn family homestead on Cobbs Creek at Ardmore and Haverford Avenues, in 1939. Morris Llewellyn purchased land from William Penn in January 1681. He and his wife, Ann, were among the first to settle Haverford Township with the hope of establishing a Welsh Barony. Castle Bith is named for their birthplace in Pembrokeshire, Wales. Date stones indicate the earliest parts of the stone house may have been built between 1693 and 1699.

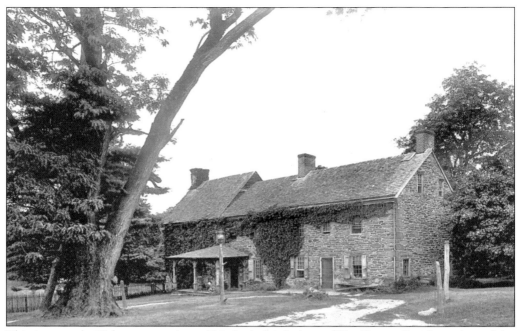

This is an early-20th-century view of Narbeth, birthplace of Dr. George Smith, author of the important work *History of Delaware County, Pennsylvania* (1862) and founder of the Delaware County Institute of Science. The original section of the house, built in 1687 by Welsh settler Richard Hayes, is the ivy-covered section with the steeply pitched roofline. It is in the middle section, built in 1799, that George Smith was born in 1804.

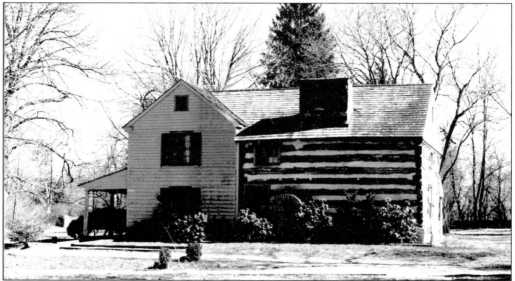

Simon Litzenberg owned the *c.* 1750 log section of the Hannum House, originally located on the corner of Darby Road and Dartmouth Lane in Coopertown. He appears in the tax list of Haverford Township as early as 1762. Built of unusual diamond-cut Chestnut logs and showing evidence of the original beehive oven, the house is listed in the 1798 Glass Tax. William Hannum purchased the house in 1883.

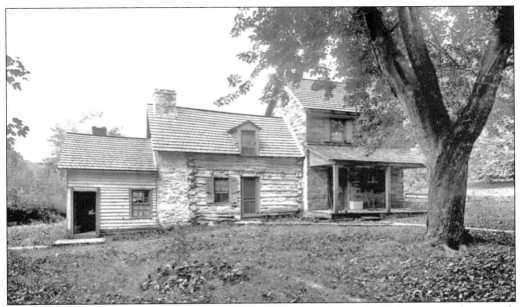

The "House of Three Generations" sports a new roof in this early-20th-century photograph from the Massey House collection. The center section is the well-known "Lawrence Cabin," with strong ties to 17th-century Swedish building techniques. Built on Darby Creek at the present location of the White Glove Car Wash, it was moved in 1961 to Powder Mill Valley and is the site of the Colonial Living Program.

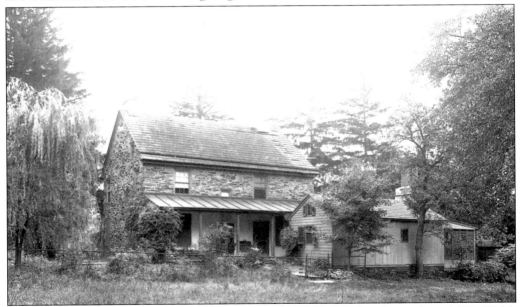

The Lawrence Homestead had its start in the small log section dated as early as 1690. Welsh Quaker David Lawrence emigrated with his wife, Elinor Ellis, in 1683, and in 1709 Henry Lawrence, their second son, purchased 209 acres of land along the Darby Creek. The Lawrence family deeded the property to descendants, thus retaining ownership in their line until the 1940s. (Courtesy of the Thomas Massey House Collection.)

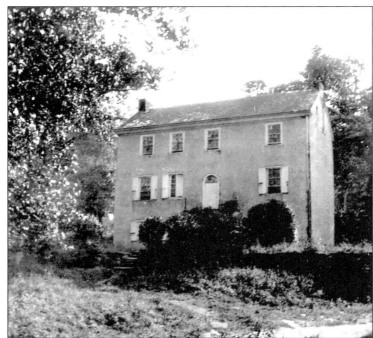

This 1917 Eckfeldt photograph shows the east facade of Nitre Hall, listed on the National Register of Historic Places and known as the Rogers House after the powder master of Nitre Hall Powder Mill. The mill flourished from 1810 to 1840, producing gunpowder for the War of 1812. In 1826, after the death of his partner Israel Whelen, William Rogers still employed 20 laborers. The entrance stair was reconstructed in 2002.

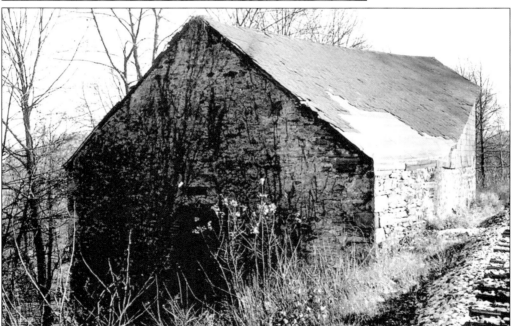

The powder magazine along the Philadelphia and Western Railway Company line between the Penfield and Beechwood Stations, was photographed in 1950 by Robert L. Fox. Used for storage of gunpowder during the mill days, it is now a ruin, owned by the Southeastern Pennsylvania Transportation Authority (SEPTA). The southwest corner of the fieldstone building was removed to accommodate the tracks. This structure and Nitre Hall are all that remain of the second-largest black-powder industry in the United States.

This 1909 photograph of the north gable end of Nitre Hall was taken by Dr. John W. Eckfeldt. The view reveals an unidentified building in the distance at the end of the ramp decline, where stone remains exist even today. The year 1909 was the year of the great storm that washed out the dam just across Cobbs Creek from Nitre Hall. The creek is named for William Cobb, who had a mill along it in Darby.

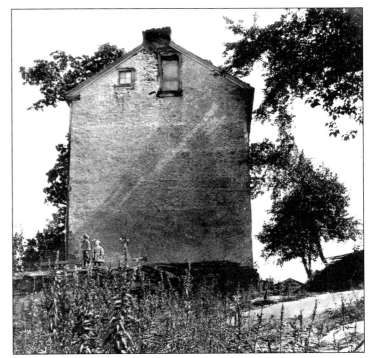

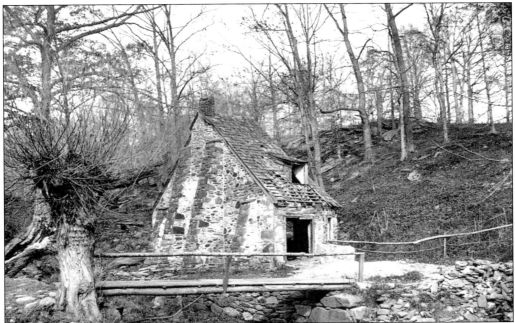

Eckfeldt took this photograph of the Drying House on Cobbs Creek c. 1900. This small house, with a buttressed exterior wall, was located on the east side of the creek. Willow trees were grown in abundance in the valley for making charcoal, an essential ingredient in black powder. The ruins of the dam are in the distance. Today, stone reinforcements to the bank of the creek can still be seen.

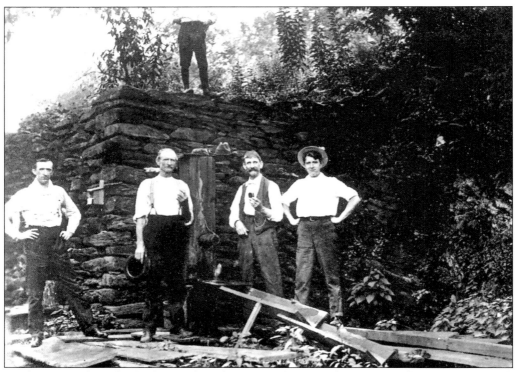

Workers pause for a drink of water from the well at the base of the ramp wall behind Nitre Hall in 1880. By 1840, gunpowder had given way to Dennis Kelly's textile mills, which employed large numbers of new Irish immigrants. During its manufacturing history, Cobbs Creek was home to mills owned by Samuel Garrigues, Manuel Eyre, Joshua Humphrey, Jonathan Miller, Joseph and Samuel Leedom, Patrick Boyle, and George Dickinson.

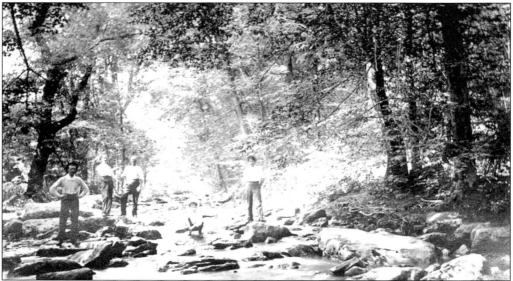

This peaceful view of Karakung Creek, now called Cobbs Creek, near the Beechwood Bridge has changed little since John W. Eckfeldt posed his subjects on the rocks in 1880.

Here are two views of Dennis Kelly's Cotton Mill, built c. 1840–1841 near the former Finelli property. Cobbs Creek is to the left, and the magazine is hidden from view. Large textile orders were filled for the Union army during the Civil War from this site, which continued in operation until the beginning of the 20th century.

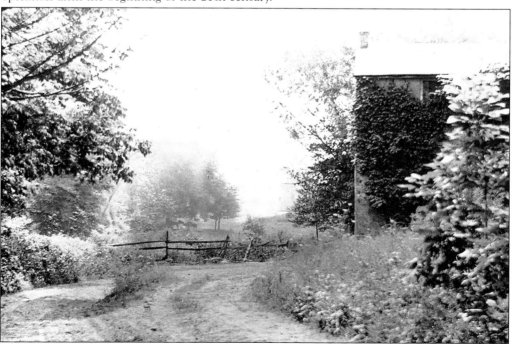

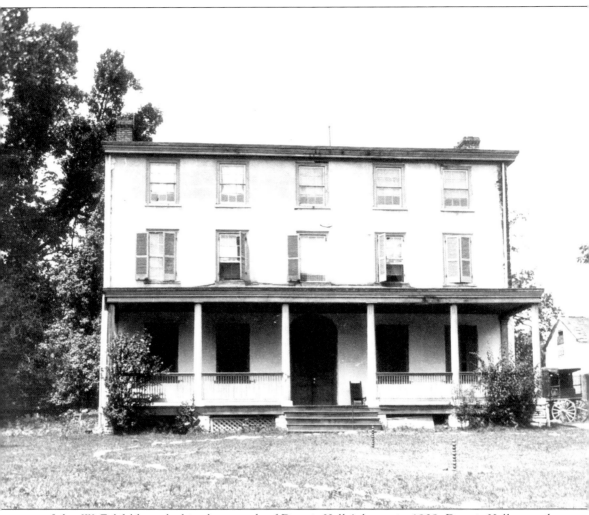

John W. Eckfeldt took this photograph of Dennis Kelly's home in 1908. Dennis Kelly was the successful owner of several mills along Cobbs Creek and benefactor of St. Denis Church. The home was located on the east side of Cobbs Creek, near the old Manoa Road Bridge. Here, at Hermitage Farm, Dennis Kelly and his wife, Mary, raised their eight children. Born in County Donegal, Ireland, in 1779, Kelly immigrated to Philadelphia in 1806 and went to work in the local mills. From 1817 into the 1860s, his mills were contracted by the U.S. government to provide cotton and woolen goods. The success of his businesses also led to the hiring of hundreds of fellow Irishmen. To accommodate his employees and their families, Kelly erected a school and founded the St. Denis Church in 1825. Dennis Kelly died on July 21, 1864, at the age of 85. He and his family are buried in the section of St. Denis Church Cemetery next to the church.

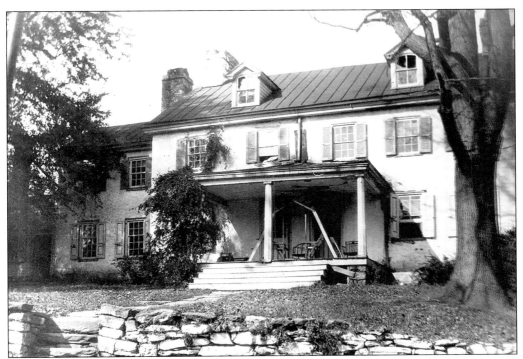

Built *c.* 1725, the earliest section of this fieldstone house, the Leedom, or Dickinson, Mansion on Mill Road still has much of its original hardware, pegged carpentry, and a very deep well. In 1810, Jonathan Miller built mills along Cobbs Creek where Mill Road meets Karakung Drive. Samuel Leedom purchased Miller's Mill in Echo Hollow in 1844. In 1879, George Dickinson bought the mills and named his road Dickinson Mill Road.

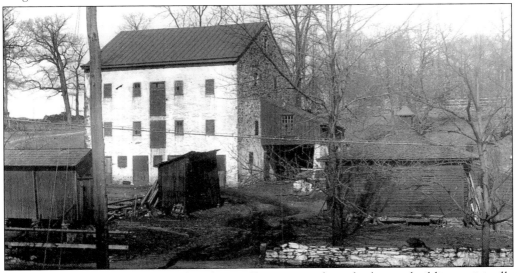

Pictured here are the Leedom and Dickinson Barn, corncrib, and other outbuildings originally part of the property on Mill Road. This site is approximately where the driveway to the Suburban Jewish Community Center–B'nai Aaron is today. The back of this barn can be seen in the synagogue groundbreaking photograph in chapter 3.

Seen here is Thomas Cochran, a shoemaker who lived to be 86. He specialized in wooden-soled shoes worn by gunpowder workers to protect against the danger of sparks set off by hob-nailed boots. Explosions in the mills were heard as far away as Philadelphia. Cochran, called "Big Tom," lived in "Widow's Row," a later, Civil War reference. Dr. Eckfeldt placed this row of dwellings on a rising elevation on the opposite side of Cobbs Creek.

This hand-drawn map of the Cobbs Creek Valley is useful for placing the numerous mills and other buildings in the area.

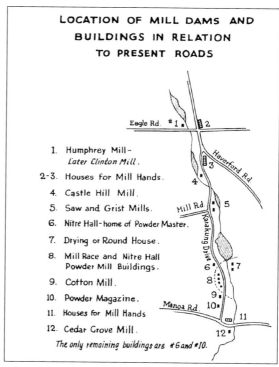

LOCATION OF MILL DAMS AND BUILDINGS IN RELATION TO PRESENT ROADS

1. Humphrey Mill – Later Clinton Mill.
2-3. Houses for Mill Hands.
4. Castle Hill Mill.
5. Saw and Grist Mills.
6. Nitre Hall – home of Powder Master.
7. Drying or Round House.
8. Mill Race and Nitre Hall Powder Mill Buildings.
9. Cotton Mill.
10. Powder Magazine.
11. Houses for Mill Hands
12. Cedar Grove Mill.

The only remaining buildings are #6 and #10.

English Row was the name given to workers' housing for Clinton Mills on the northeast corner of Haverford and Eagle Roads, called Church Road on the early maps. These homes enjoyed a view of the millpond at one time. The photograph was taken in 1959.

The Old Haverford Store is seen here as it appeared in 1908. This was a popular meeting place for mill workers and for a short time was a post office at the busy intersection of Church and Haverford Roads.

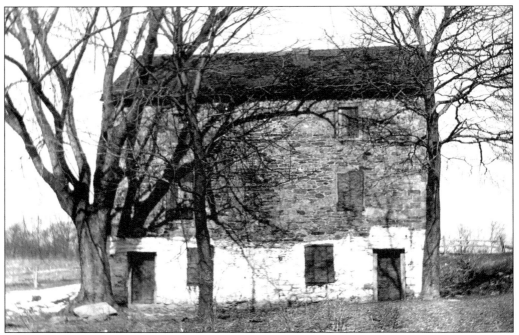

Typical mill-style buildings were often converted to housing. A similar structure may be glimpsed in an early panorama of the valley taken for promotional material for the Penfield development. Karakung Drive was not a public road in the mill days, and for safety sake, most housing was located well away from the mill operation. Brass polishing balls could be blown up to a half-mile away.

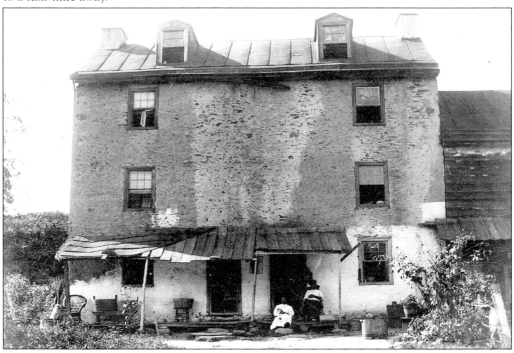

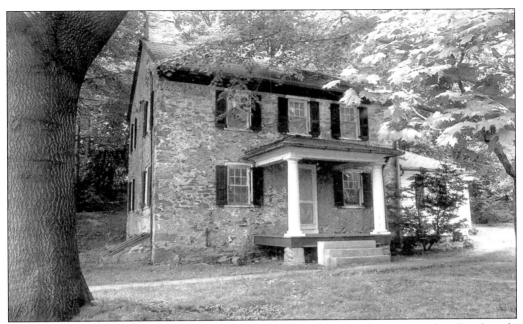

The Frog Tavern, on Darby Road across from the old springhouse on the Quadrangle property, served as a tavern as early as 1731, when Griffith Evans was proprietor. According to Dr. George Smith in *History of Delaware County, Pennsylvania*, Evans and his wife "kept the well established stand known as the Old Frog." The inn was convenient for travelers along the Darby Road, which was laid out in 1687.

The crisp detail and depth of field visible in this photograph are achieved by a printing from a glass-plate negative in the Samuel Sellers Collection at the Sellers Library in Upper Darby. The dilapidated house is Dickenson's Old Farmhouse, off Coopertown Road. The exact location is not known.

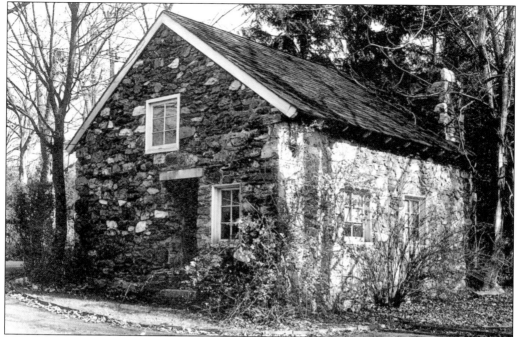

In 1950, Robert Fox photographed the home of the cooper on Darby Road opposite the 1797 Federal School, from inside the cooperage property. It looks much the same today. Coopertown was the first area of the township identified for its industry. The cooper and the blacksmith, who lived on the corner across Dartmouth Road, combined skills to produce barrels essential for the storage and shipping of everything from grain to gunpowder.

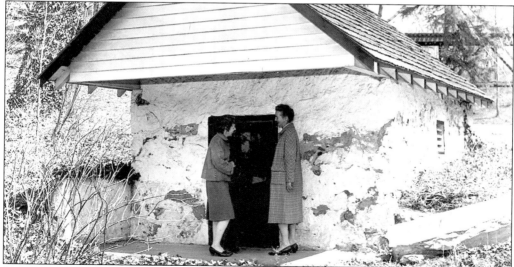

Betty Stafford (left) and Margaret Johnston, historical society members, stand outside the springhouse on the Brookthorpe Station property on Marple Road in 1962. The train trestle visible in the background once carried freight tracks along the Darby Creek to Newtown Square. The 1875 right-of-way for the Philadelphia and Delaware County Railroad ran by the house. The late-18th-century stone home on this property retains many original features.

Two

ROADS AND RAILS

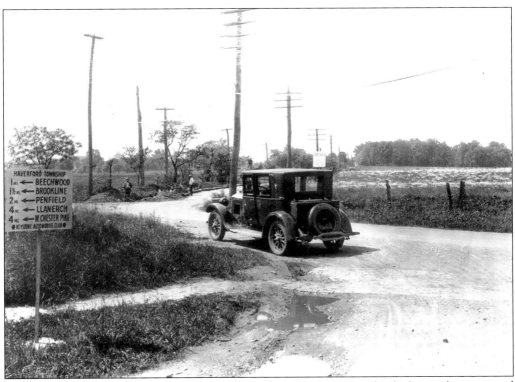

In this 1925 photograph, the driver of a 1924 Hupmobile stops to check the road sign posted by the Keystone Automotive Club. This view looks north along County Line Road from the intersection of Haverford Road. The Sunday drive became popular in the 1920s with the increase in car ownership, gas stations, improving road quality, and maps. Hotels and resorts advertised to encourage family trips. (Courtesy of the Hagley Museum and Library.)

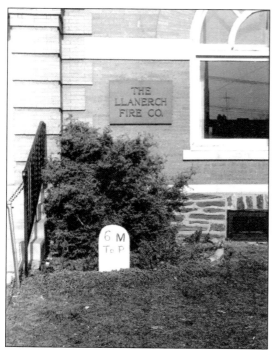

With no maps or street signs, William Penn in 1683 ordered all roads to be "laid and marked." Mile markers made of granite or marble were set up on major roads to assist travelers and were used as landmarks to give directions. This mile marker, preserved at its original location on West Chester Pike by the Llanerch Fire Company, indicates that it is six miles to Philadelphia.

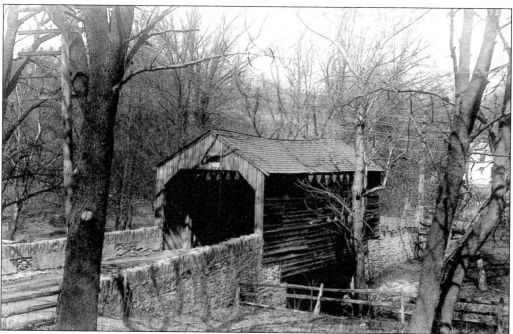

In 1920, this covered bridge on Darby Road near Sproul Road crossed Ithan Creek. Dating back to 1687, the bridge was remodeled in 1932. Bridges were covered to protect the bridge's trusses from deterioration due to weather. Darby Road was at one time known as Coopertown Road, where it passed the Cooperage. Other historical landmarks such as the Frog Tavern, Federal School, Allgates Estate, and Linden Hall were located on or near Darby Road.

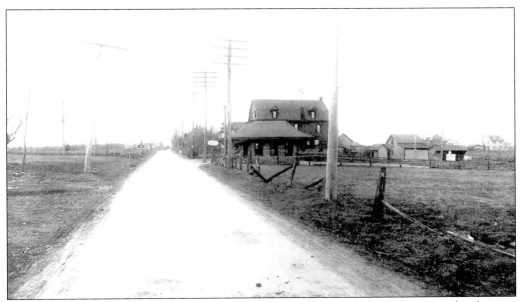

This eastbound view of Eagle Road at Oakmont *c.* 1907 shows the small station for the new Ardmore trolley line. Originally named Church Road, Eagle Road was later named after the Spread Eagle Hotel. The hotel was located on Eagle Road and West Chester Pike. The open land to the right and left became the Oakmont Business District. In the distance to the left is the site where the Oakmont School would later be built.

By 1922, the same view of Eagle Road reveals the current Oakmont Elementary School, pictured to the left. It was built in 1911 and originally served as the Haverford Township High School. Other main roads used to travel to mills, Quaker meetinghouses, and market areas were Darby Road, Haverford Road, and Mill Road. Farther east were St. Denis Church and the Haverford Friends Meeting House and Burial Grounds.

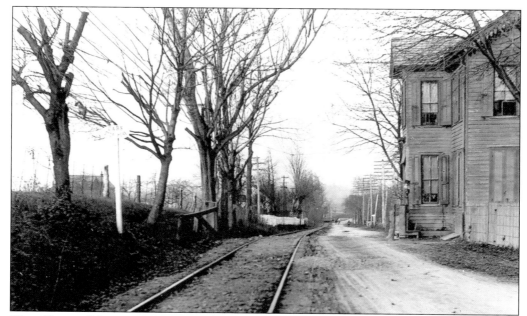

West Chester Pike was once a privately owned turnpike used to travel to Philadelphia markets. Tolls of 1¢ for each horse or mule and 1½¢ for each heavy wagon or coach were collected at Toll Booth No. 4 in Manoa. Churchgoers and funeral processions were exempt from the toll charge. The toll collectors lived in the building and in some cases were postmasters.

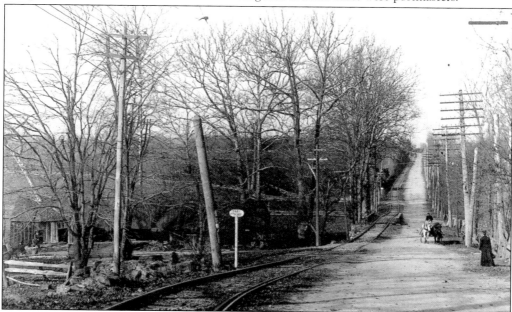

Farmers and business owners held shares of the turnpike. The 24-mile hemlock-wood-plank road to West Chester was built in sections, the first of which reached Eagle Road in 1848. Taverns served as post offices, delivery stops, and rest stops for travelers. Snite's Stage Coach, the only public transportation available, cost 75¢ to Newtown Square. This westbound view includes the Lawrence Saw Mill, built in 1837, near Lawrence Road.

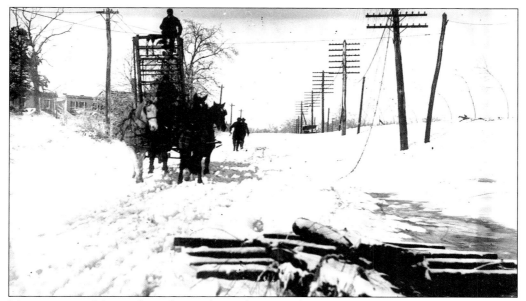

Maintenance of the tracks and turnpike in this 1903 sleet storm proved difficult. When money for maintenance of the wood-planked turnpike was drying up, railroad tracks were laid on the south side of the pike planks in 1859 for a horse-drawn rail coach. In 1865, steam-engine trolleys were attempted, but the noise disturbed horses on the turnpike. In 1896, John Shimer began electric car service to Newtown Square.

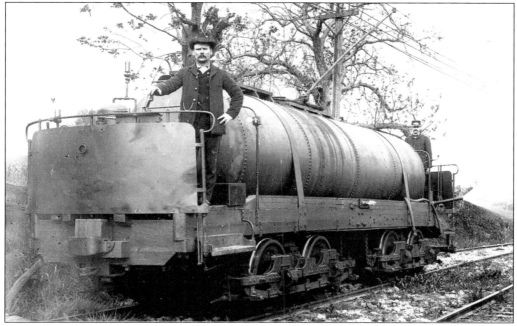

One complaint travelers on the trolley voiced was about dust stirred up by the horses and wagons on the turnpike on hot, dry days. The dust would fly into the trolley, choking the passengers. Sprinkler cars like the one in this photograph would sprinkle water on the turnpike to reduce the dust. The water was sprayed from a nozzle at the rear of the car.

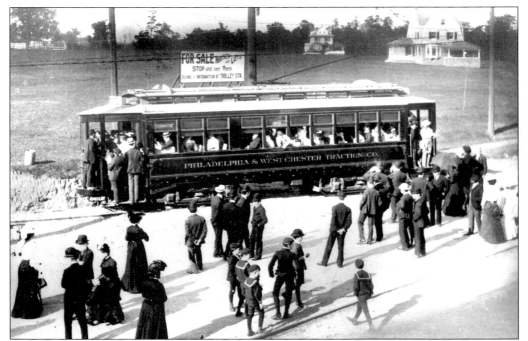

With the success of the West Chester trolley line, the Philadelphia and West Chester Traction Company opened a new branch from Llanerch Junction on West Chester Pike to Ardmore in 1902. Pictured above is a view at Llanerch on opening day. The Ardmore line ran on Darby Road to Ardmore Junction. In the distance, signs can be seen indicating lots for sale in the new planned community of Llanerch.

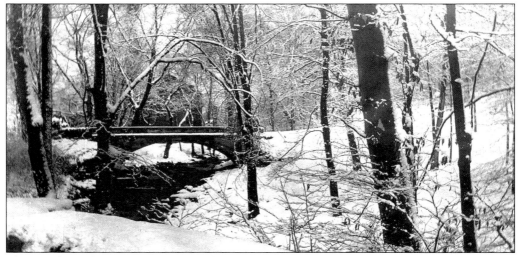

The Beechwood community is entered by crossing this small bridge at the Beechwood Station of the Philadelphia and Western Railway Company. Much of the beauty of this creek and park remain thanks to the efforts of the community. In 1927, local residents contributed money to purchase eight acres from John Cadwalader's estate to form a trust for the preservation of this land as a park "for the health and enjoyment of the public." The township now owns and protects this area.

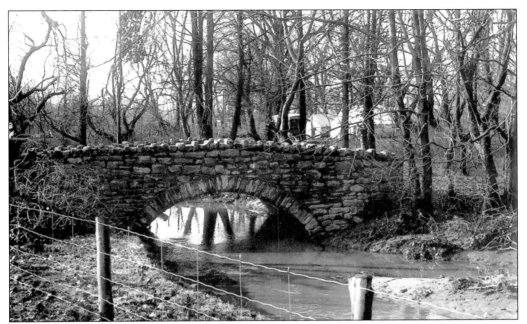

This early photograph by Wilbur Hall, taken along Cobbs Creek near Haverford College, shows a small stone bridge that crosses over the stream to connect Haverford and Ardmore Avenues. The tents in the distance are occupied by a group of gypsies who settled here for a short stay.

Wilbur Hall's photograph, taken in the early 1900s, shows how the Ardmore line winds through the woods parallel to the Cobbs Creek as it makes its way through the area along Haverford Avenue near Merion Golf Manor and Haverford College. Gypsy tents, in the distance, provide little protection against the winter chill for the families who stayed on.

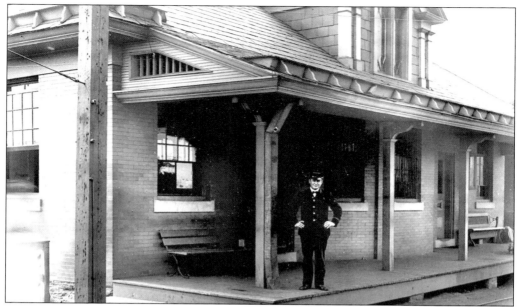

This 1900 photograph depicts the newly constructed stone office building of the Philadelphia and West Chester Traction Company. Twenty-four-year-old businessman A. Merritt Taylor managed to take control of the faltering trolley line just one year before and oversee the construction of this structure and numerous other improvements to the rail line. For 71 years, Taylor, with his son and grandson, controlled and expanded the company, making it one of the most successful privately owned suburban transit companies in the world.

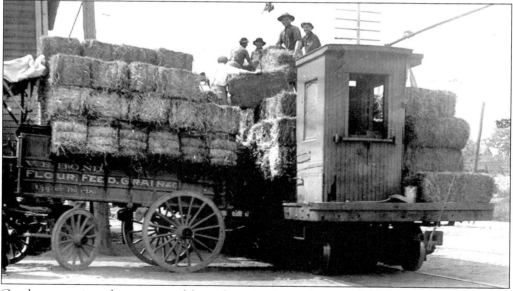

Goods were primarily transported by rail car in the early part of the century. Pictured here are men unloading a carload of hay onto a horse-drawn cart. The wagon belongs to Van Leer Bond Flour, Feed, Grain and Company of Upper Darby. The Llanerch, 63rd and Market Street (Millbourne), and Newtown Square junctions were major stops for Philadelphia supply trains to deliver goods to local farmers and businessmen.

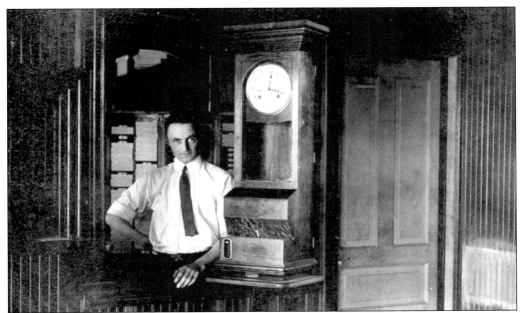

Here the ticket master at Llanerch Junction waits to serve the next traveler. A ticket to West Chester cost 35¢ in 1917. The trip from 63rd Street in West Philadelphia to Newtown Square took 1 hour and 15 minutes by steam engine and frequently ran late. The steam engines had a difficult time traveling up the West Chester Turnpike hills. In 1896, electric cars cut the travel time by a half-hour.

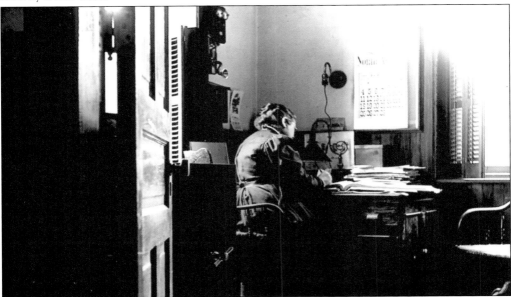

This great interior shot by Wilbur Hall shows a woman working at the Llanerch Junction office, performing her bookkeeping duties without the aid of computers, calculators, and good lighting. In the summer, the cross breeze from the two windows would provide the only air conditioning available. Records were tallied by hand for the accountant. Notice that you would have to stand every time you needed to use the phone.

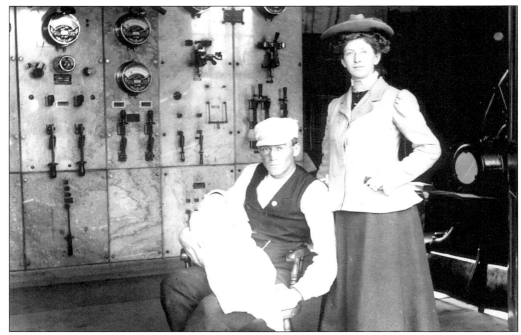

Llanerch resident Wilbur Hall, born in 1879, is pictured here with his wife and infant in the engine room of Llanerch Junction. He worked as chief engineer for the Philadelphia and Suburban Transit Company until his retirement in 1929. Haverford Township is fortunate to have had this man within its midst. Many of the photographs in this chapter were taken by Hall between 1900 and 1913.

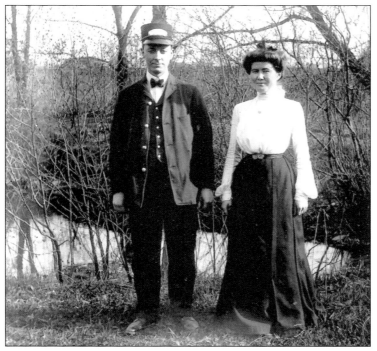

An interview with Wilbur Hall in his later years conveys the story that here, Herbert Watson, a motorman, and his fiancée, Lillian Thompson, pose as they prepare to leave to be married. Watson most likely worked extremely long hours, and so stealing a moment for a snapshot was a real luxury.

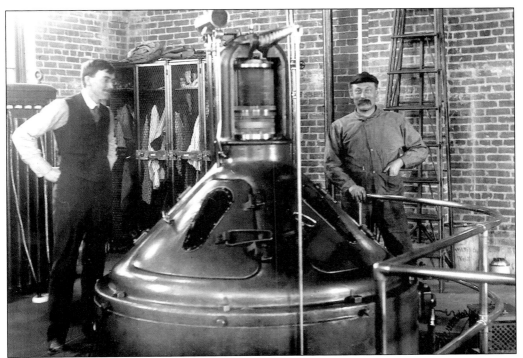

Wilbur Hall stands with another workman in the boiler room. The turbine machine and steam boiler were necessary in providing power to the railroad cars. The Llanerch Junction Power Station was located on the south side of West Chester Pike to the west of Darby Road. The trolley barn, located on the same site, was converted to a bus barn in the 1950s, when bus service replaced the trolley.

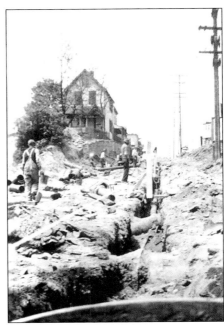

To help states and local communities during the Great Depression, Congress established the Federal Emergency Relief Administration. In 1935, the Work Projects Administration was formed. Under this program, Haverford Township received money and manpower to make improvements to the storm water sewer pipes along Darby Road. This photograph shows the massive job of laying in pipe between West Chester Pike and Township Line Road.

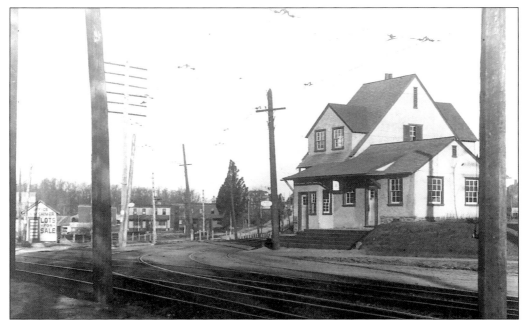

At Llanerch Junction, the Ardmore line branches off West Chester Pike onto Darby Road. The stores on the west side of Darby Road have not yet been built. The small wood real-estate office entices travelers to make Llanerch their home. Llanerch was one of the first neighborhoods developed after the Philadelphia and West Chester Traction Company began operation. Trolley service on this line continued until 1966.

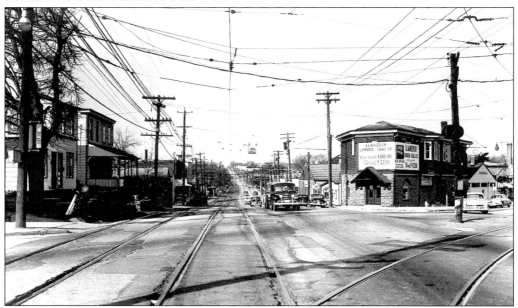

This photograph, taken by Bob Fox, shows that by 1952, the intersection of West Chester Pike and Darby Road needed work, thanks to the growing population and increased use of private automobiles in the suburbs. The houses on the left were torn down to widen West Chester Pike and enlarge the Red Arrow carbarns.

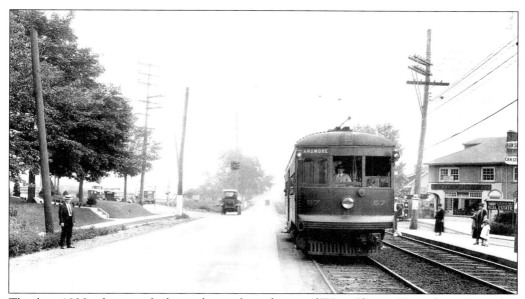

This late-1920s photograph shows the eastbound view of West Chester Turnpike at Township Line Road. A sign of things to come, a new Chevrolet showroom is visible on the right. The site on the far left (near the man with the straw hat) is now occupied by commercial developments. The No. 57 trolley, with a center-door entrance, was scrapped in 1958. (Courtesy of the Hagley Museum and Library.)

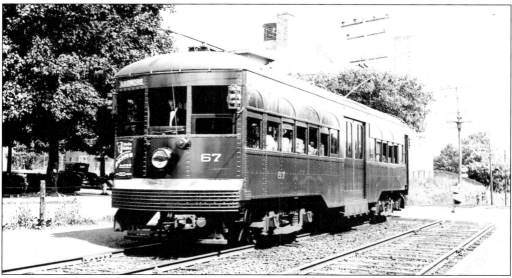

Traveling north on Darby Road, the No. 67 trolley clears the stop at Llandillo Road. The Llanerch Elementary School, with its recognizable cupola, stands just behind the trolley. Notice the grassy bank along the school property. Moewyn Road, a tiny street that connects Lansdowne and Darby Roads, has not yet been cut through at the time of this photograph. (Courtesy of the Hagley Museum and Library.)

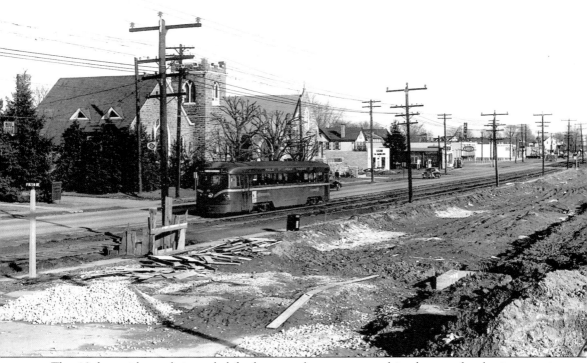

The 18-foot-wide road, intended for horse and wagon, proved inadequate for the increase in traffic by the 1950s. This photograph shows the West Chester Pike expansion to two lanes on either side of the trolley track. Both the old and new Trinity Lutheran Churches are shown here. In the 1970s, environmentally friendly grass plots were planted when the tracks were removed.

Three

FEED THE SOUL

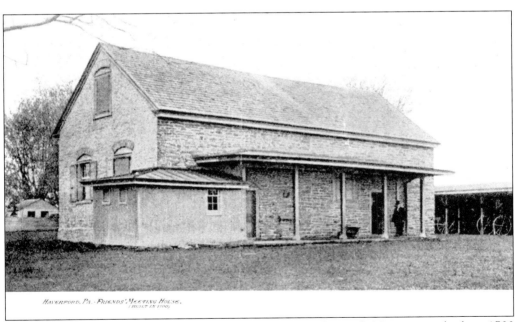

HAVERFORD, PA.- FRIENDS' MEETING HOUSE.
(BUILT IN 1700)

After meeting in private homes for 16 years, the Haverford Friends Meeting was built in 1700 by the early Welsh settlers. Located on Eagle Road and St. Denis Lane, this is the oldest place of worship in Delaware County. The original tract of land encompassed all the land up to and including the Friends Burial Grounds and land leased to the St. Denis parish for their church and cemetery. (Courtesy of the Keith Lockhart Historical Collection.)

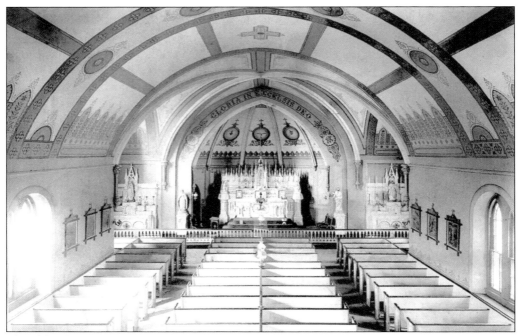

The oldest known interior view of St. Denis Church, taken before electricity was installed, shows oil lamps on the center pews. St. Denis is the first Catholic church building in Delaware County. In the early days, priests from Villanova College performed the clerical duties for the congregation.

The Haverford Friends Meeting, on Buck Lane, was built in 1834 after 70 members of the Radnor Meeting chose to follow a more orthodox interpretation of their religious doctrine. The building was constructed so that a partition separated the men from the women. A footbridge and path were made so that students from Haverford College could have easy access to the meetinghouse.

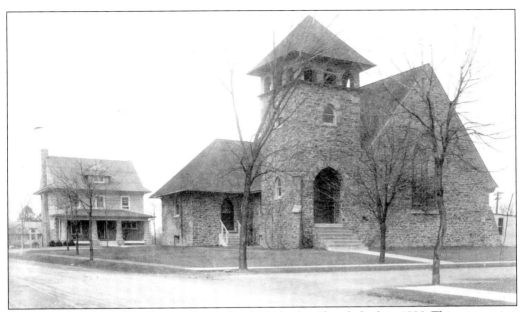

Llanerch's first place of worship was St. Andrew's Methodist Church, built in 1898. This winter view of the church, taken from Lansdowne Avenue looking toward Llandillo Road, was photographed by Wilbur Hall. Architect Frank Hays made additions in 1914, and Wesley Blithe completed a larger addition in 1922. (Courtesy of the Keith Lockhart Historical Collection.)

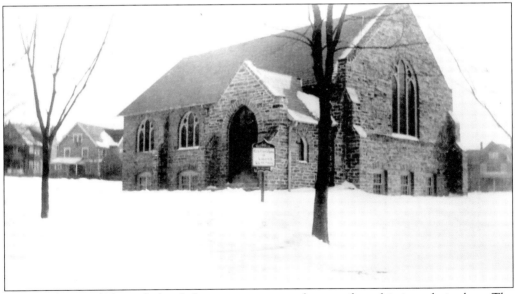

The developers of Llanerch decided to incorporate two houses of worship into their plans. The second of these was the Llanerch Presbyterian Church. George Nattress, whose firm specialized in churches in the United States and the United Kingdom, designed the building. A block from West Chester Pike and Darby Road, the Gothic style, and locally quarried stone gave the church an old Welsh county feel.

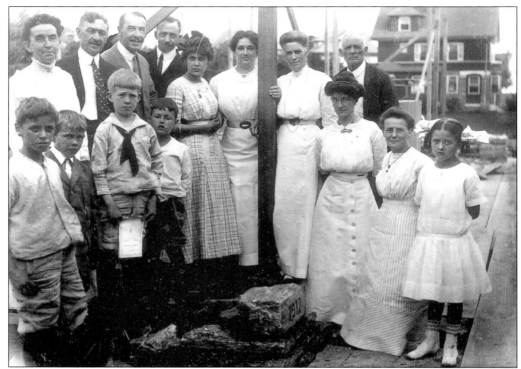

Several church members watch as the cornerstone, dated 1912, is ceremoniously placed near its final destination at the Llanerch Presbyterian Church. Wilbur Hall, one of the charter members of the church, took this photograph to mark this special occasion. Other founding fathers listed on the charter are George D. Moore, J.E. Dunwoody, Wilfrid L. Coates, and John C. MacAlpine.

Umbrellas, hats, and hands are used to shield the eyes of these very young onlookers in another Wilbur Hall photograph. Some old-time detective work helped to identify the location of this setting, but the purpose of this gathering, close to the Llanerch Presbyterian Church, remains a mystery.

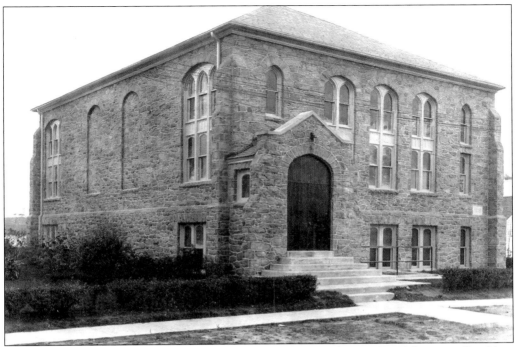

The Temple Lutheran Bible School Building, located on Earlington Road between Brookline Boulevard and Sagamore Road, was built in 1919. It served the residents of the Brookline and Penfield areas not only as a house of worship but also as a place for civic and educational meetings.

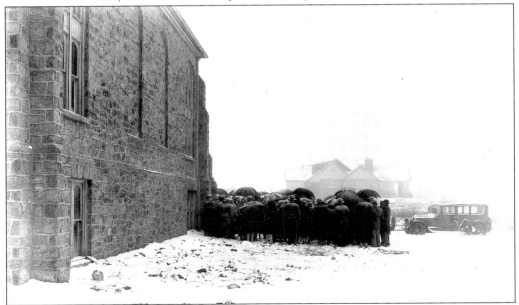

Members of the Temple Lutheran Church huddle together on a snowy December morning in 1926 to witness the groundbreaking for a new church sanctuary. Growing church membership required that an addition be made onto the original Bible School Building. On close examination, the mode of transportation that day was by foot, auto, sled, and even baby carriage.

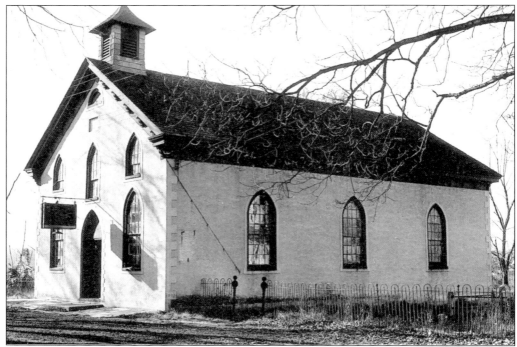

Pictured here is the former Bethesda Methodist Church, located on Manoa Road, near Grand Avenue. Built in 1832, the church thrived, and a new facility was eventually needed. The building was sold and used as the Odd Fellows hall. In 1942, the renamed Ebenezer Methodist Church moved into their new building at Steele and Eagle Roads.

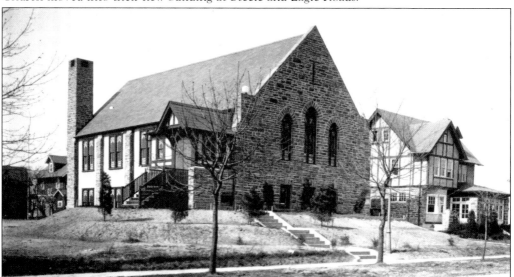

In 1922, the congregation of the Brookline Methodist Episcopal Church moved from their former place of worship in the Cobbs Creek School to the new sanctuary at Brookline Boulevard and Allston Road. The church has undergone numerous alterations since this photograph was taken, including its name—Union Methodist Church. (Courtesy of the Keith Lockhart Historical Collection.)

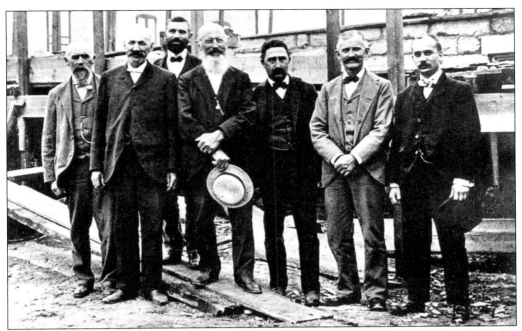

These proud men stand in front of the framework for the Trinity Lutheran Church in this photograph from 1902. Charles Gettz donated the property for the church. The charter members seen in this photograph are, from left to right, Thomas H. Hughes, David Gettz, Herbert Gettz, Charles W. Gettz, Hayes Anderson, Franklin Gettz, and Howard H. Gettz.

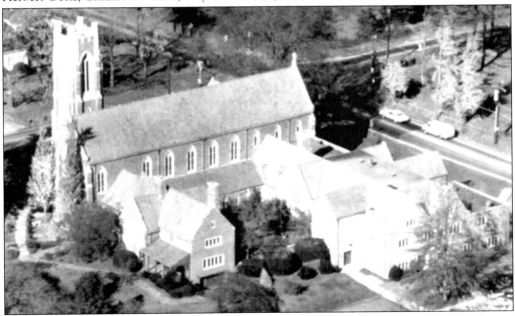

This spectacular aerial view of St. George's Episcopal Church conveys the grand plan George Washington Nevil had for the church he envisioned to honor his parents. Construction of the edifice began in 1929 under the direction of William Heyl Thompson of the architectural firm Watson, Edkins and Thompson. The congregation held its first church service on April 4, 1932.

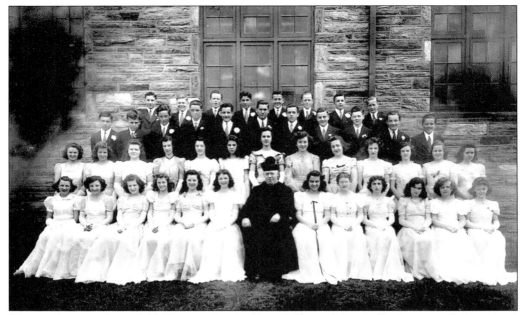

The graduating class of 1943 poses beside Sacred Heart School. Dedication of the school and church building took place on November 3, 1928, with Rev. John Hickey as its first pastor. During the early years, students were bused from as far away as Edgmont. By 1951, the congregation grew from the original 43 families to 1,400 parishioners.

The Annunciation of the Blessed Virgin Mary parish celebrated mass and other church functions in the Brookline School and also a private home until the building was completed in 1928. A new sanctuary was constructed in 1955 under the direction of founding pastor Reverend Cahir. Following the deaths of Father Cahir and Father Donnelly, Fr. John Haydt, J.C.D., was named pastor in 1957 and led the church through several expansions.

Twenty Jewish families conceived the idea for the Suburban Jewish Community Center in early 1952. Groundbreaking took place on September 12, 1955, on the site of the Leedom Farm situated between Mill and Earlington Roads. In 1956, Temple Tel Or was added to the center's name, signifying "Hill of Light." When another congregation merged in 1969, the name was changed to Suburban Jewish Community Center–B'nai Aaron. (Courtesy of the Philadelphia Jewish Archives Center.)

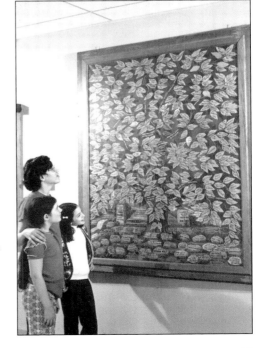

These children are looking for their families' names on the "Tree of Life" at Suburban Jewish Community Center–B'nai Aaron. The tree, a traditional symbol of life in Judaism, is used here as a dedication to the families who have made contributions to the synagogue over the years. (Courtesy of the Philadelphia Jewish Archives Center.)

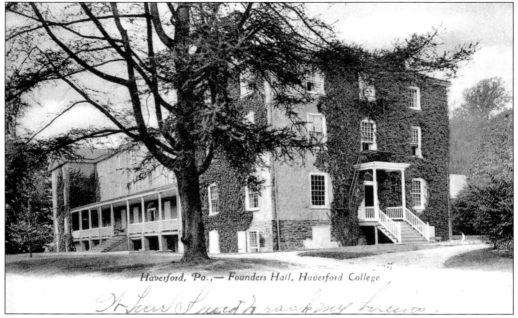

Haverford, Pa., — Founders Hall, Haverford College

"We wished to procure a farm in a neighborhood of unquestionable salubrity—within a short distance of a Friends Meeting—of easy access from the city at all seasons of the year—recommended by the beauty of the scenery and a retired situation." This proclamation by the Society of Friends marked the beginnings of Haverford College. Founders Hall was erected in 1833. (Courtesy of the Keith Lockhart Historical Collection.)

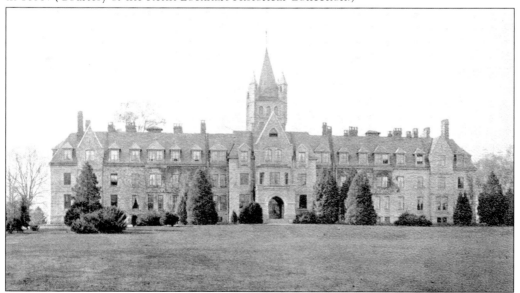

In 1834, Samuel Garrigues sold two acres of his land to the Haverford School Association for the first Quaker college in America. In 1873, football was added as a sport, and four years later, increased attendance necessitated the construction of a new dormitory building. Barclay Hall's configuration allowed for three-room suites, providing students with comfortable space for studying and sleeping. (Courtesy of the Keith Lockhart Historical Collection.)

Four

FUEL THE MIND

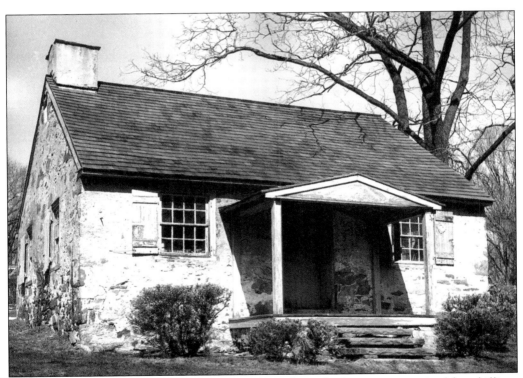

A deed recorded on November 7, 1797, states that Alexander Symington received five shillings in payment for his "land situate in the said Township of Haverford Beginning at a stake in the line of land of Simon Litzenberg . . . containing one quarter of an acre and three perches" on Darby Road in Coopertown "for the purpose of erecting a school house thereon, for the use of the said Township of Haverford." Among the trustees of this first school building in Delaware County was Benjamin Hayes Smith. Restored for the bicentennial, it is used every spring for the "One Room School Experience."

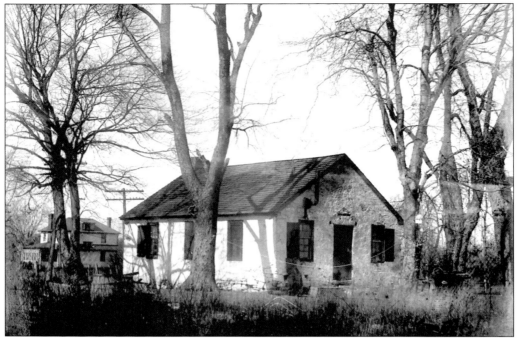

Haverford Seminary No. 2, built in 1846 near the corner of Steele and Eagle Roads in Bon Air, rests on the footprint of an earlier school. Called Edgewood, the school burned in 1879. The students moved across the street to a new school, now a private home on Eagle Road. In this 1930 photograph, from N.B. Clark, the impression of the original date stone, now in the Manoa School lobby, is visible in the gable end.

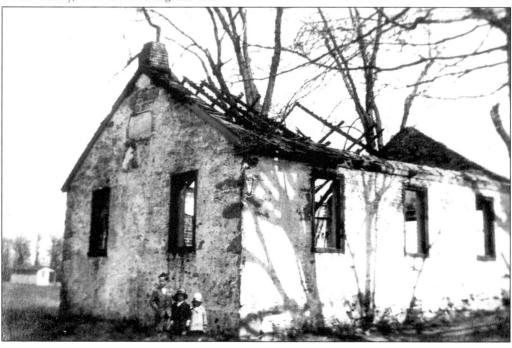

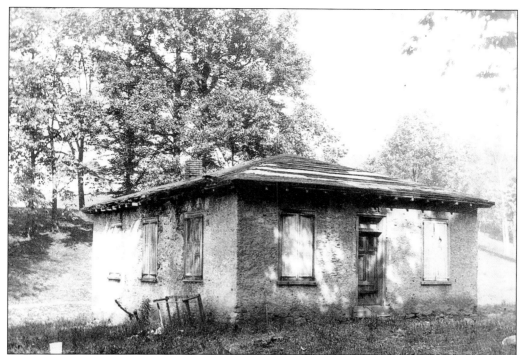

Known now as the first St. Denis School, Kelly's School was located in the valley of Cobbs Creek on Sarah O'Connor's land east of the mills. It served as a school for the children of Catholic workers in Dennis Kelly's mills in the 19th century. Lay teachers were supplied by Villanova College. The building was torn down in 2000 for new homes.

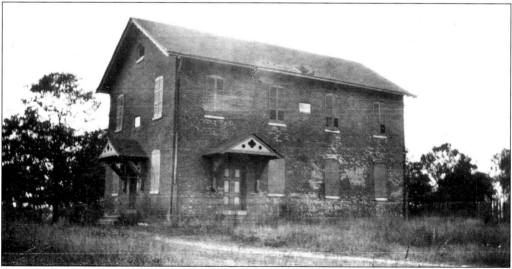

Penn Hall, on Darby at Coopertown Road and close to the Federal School, was on the property of Horatio Gates Lloyd. This photograph was taken in 1911. Penn Hall served as a school and municipal building for many years. Erected in 1872 and in use until 1910–1912, it is the original Coopertown School. The second floor was used as a community center, providing a place for political debates and dances.

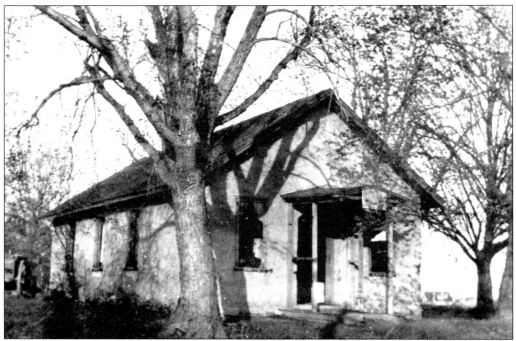

This one-room schoolhouse, called the Old School or Cobbs Creek School, was in operation from 1830 to 1890. The building was remodeled in 1854 for an increasing population, and congregations in need of space held Sunday school classes and church services here. The school, located on Earlington and Strathmore Roads, is now a private residence.

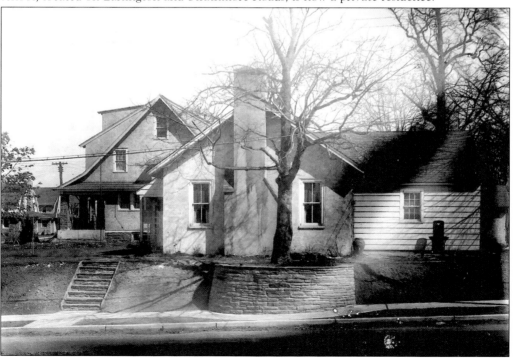

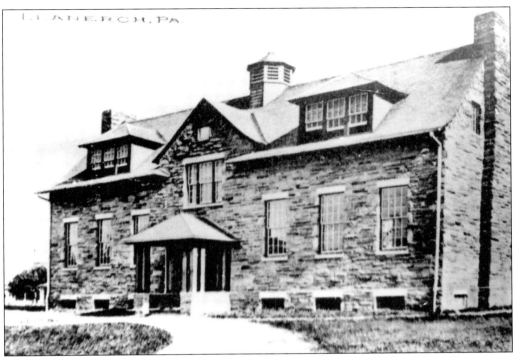

The Llanerch School, designed by Clarke Churchman and built in 1905 at Llandillo and East Darby Roads, served not only as a grade school for many years but also as the first venture into high school with a two-year curriculum. In 1906, there were two graduates.

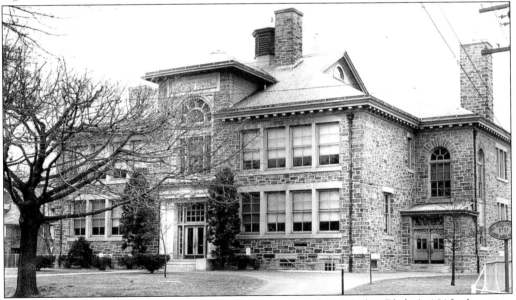

The earlier Llanerch School was completely incorporated in Wesley Blithe's 1913 alteration for the school board, but the octagonal cupola still straddles the roof ridge. Strafford Friends School purchased the building in 1986. The grounds behind the building are now used as a township park.

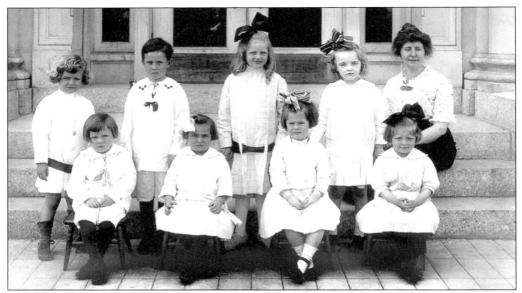

All dressed in white, these young students gather with their teacher on the front steps of the Llanerch School *c.* 1914. The two boys, whose shirts are accented with buttons and ribbon, are certainly related in some way. The child at the upper left, with the thick blond hair, is presumably a boy since the coat buttons are left over right, which is the traditional style for men's clothing.

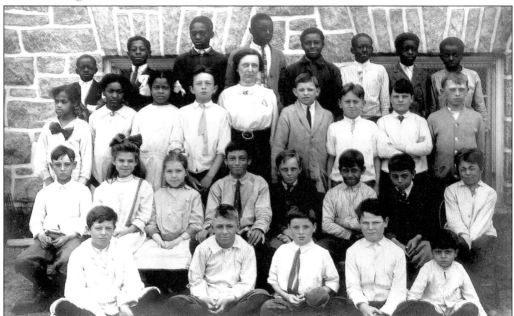

This *c.* 1913 class picture was taken beside the newly constructed Preston School. The original Preston School, built in 1876, was just west of Railroad Avenue and Buck Lane on Martin Avenue. The size and diversity of this class reflects the economic makeup of that neighborhood at the turn of the century. In the 1950s, to provide equal opportunity in education, Preston School was closed and the children were sent to Coopertown Elementary.

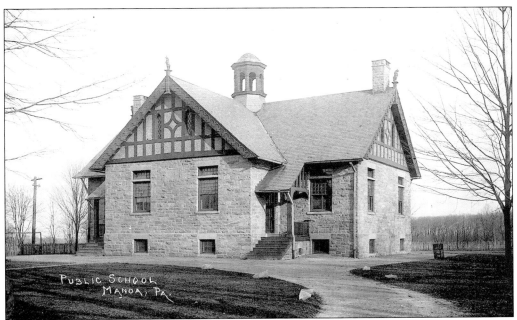

Manoa has had several schoolhouses since 1846, when Haverford Seminary No. 2 was built. From c. 1879, when Haverford Seminary No. 2 burned, to 1896, another school was erected on John Leedom's land. It is now a private home on Eagle Road. This undated photograph probably shows an expansion of the two-room English Tudor–style schoolhouse, the first to be called Manoa School, erected in 1897 at the present location of Manoa School.

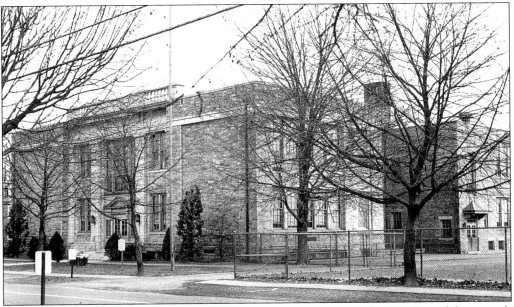

The population of Haverford Township ballooned between 1900 and 1925. Out of this growth came the need for the present Manoa School, built in 1928 on Manoa Road at Furlong Avenue. Several expansions of the building have been necessary over its long history, and in 1997, a centennial book was printed to accompany the celebrations.

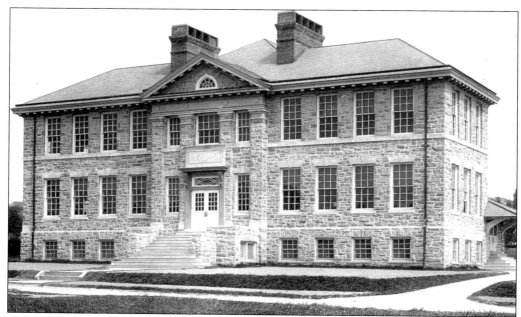

Institutional design changed little from school to school, starting with the architecture of the Chestnutwold School in 1904. There are only minor differences between the Preston School, built in 1913, and the 1912 Oakmont School on Eagle Road. Also compare the Llanerch, Brookline, and Middle Schools, all built during the population boom of the first decades of the 20th century.

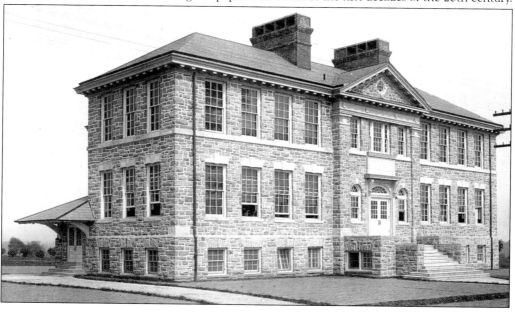

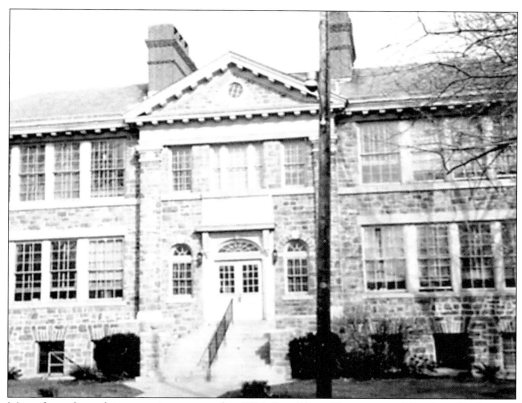

More formula architecture is seen in the 1913 Brookline Elementary School on Earlington Road between Sagamore and Kenmore Roads. When the school opened, it consisted of four classrooms with students only filling two of these rooms. Several additions followed.

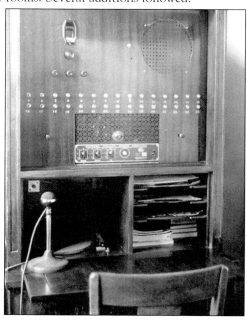

The Chestnutwold School's office switchboard-intercom was brand new in 1947, when morning announcements were heard in all the classrooms for the first time. Note the turntable just behind the microphone. It is remarkable that fifth-graders ran this equipment. This photograph is from Dr. Blair Daniel's collection.

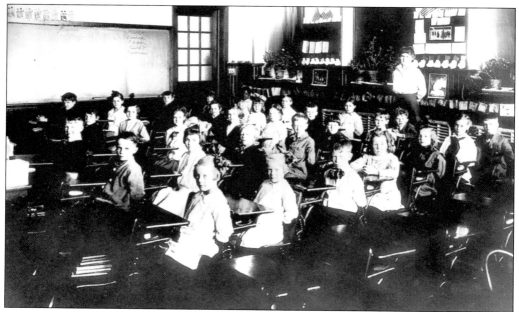

Oakmont School was the first Haverford High School and was used for that purpose until 1923. At the same time, several rooms were also occupied by first through eighth grades. Students were expected to be on their best behavior, and at the Oakmont School, there were no exceptions. Note the five names listed on the blackboard. Perhaps they were written there as warning notices for no recess.

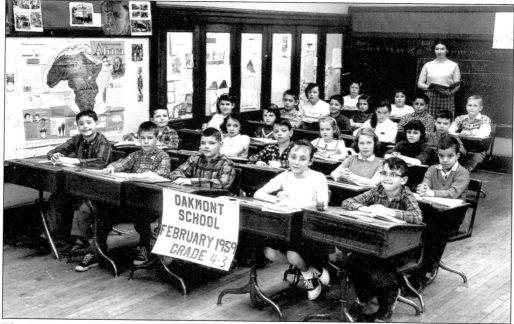

This 1959 photograph shows that some things never change. Irene Hess's fourth-grade students are posing in a similar way as their predecessors did years before. The practice of individual photographs for each student was not adopted until a few years later.

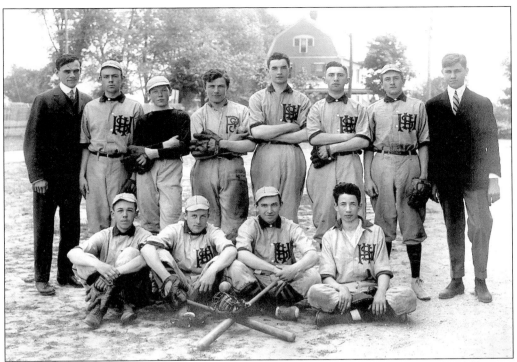

Haverford High School's baseball team poses in 1914. From left to right are the following: (front row) Luther Hagy, Edward Souder, Charles Brooke, and John Donohue; (back row) Ammon Kirshner, Don Mercer, Bill Newlin, Jimmy Dykes, Francis McShane, Raymond Brooke, Edward Souder, and Richard Atkinson. Jimmy Dykes, a stellar athlete who would play with the Philadelphia Athletics, wears a different uniform. Dykes probably played on several teams.

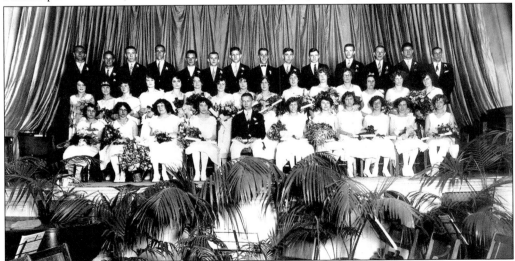

Members of Haverford High School's 1925 graduating class pose proudly on the stage of the high school auditorium after receiving their diplomas. Class valedictorian Bob Cunningham is seated front and center. Graduation was held biannually, in January and June. You cannot help but pity the orchestra trying to play in the jungle of potted palms.

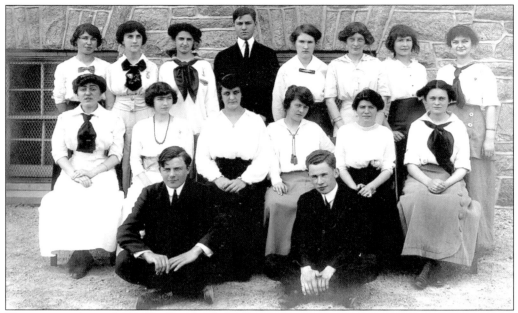

The senior class of 1914 gathers outside the Oakmont School. It was considered a great achievement to graduate from high school back in those days. From left to right are the following: (front row) Jimmy Dykes and Emery Freeman; (middle row) Anna Shupert, Martha Dunwoody, Bertha Shortland, Jean Arnold, Florence Shupert, and Sara Hughes; (back row) Mamie Howard, Florence Neal, Margaret Foster, Richard Atchinson, Nellie Mann, Jennie Cowan, Emily Henzy, and Frances Lee.

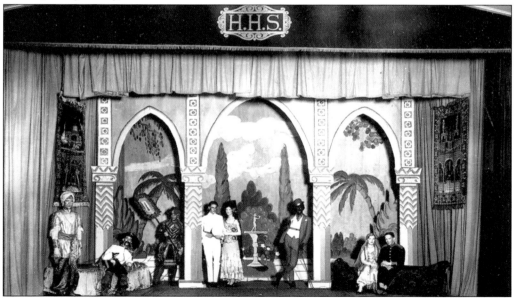

Students performing in the Haverford Senior High School Minstrel Show of 1927 have their picture taken during dress rehearsal. Fortunately for us, Mae England, an Haverford High School alumnus, carefully preserved this photograph that provides a glimpse at the genre of entertainment being performed during the Roaring Twenties.

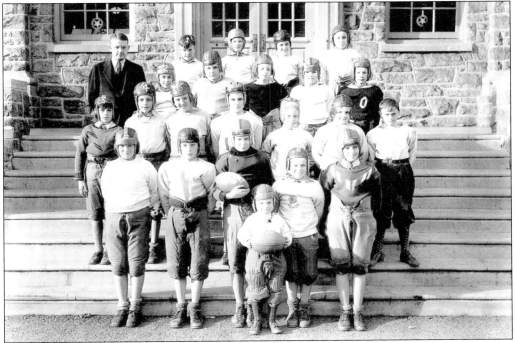

The Oakmont Grade School's football team stands with their principal, William Laramy, in this 1933 photograph. It looks like the boys were hastily pulled from practice because only one of them is wearing the Oakmont jersey for the photograph. We can only hope that the little guy in the front was a mascot.

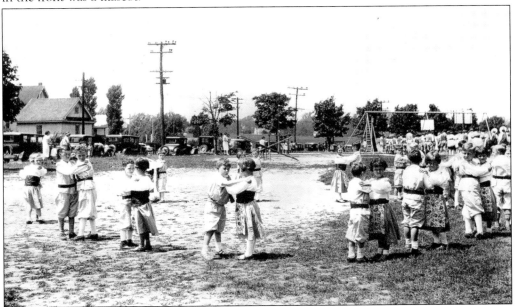

The lower-grade Oakmont School students perform a traditional dance on May Day, a popular tradition within the school community. Although the photograph is not dated, judging from the automobiles parked beside the playground, this event took place in the 1920s.

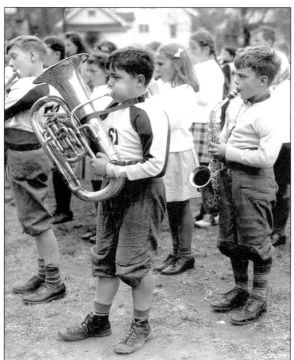

This undated photograph shows boys and girls at band practice. It is hard to imagine these football players pulling off their team uniforms to play their instruments at halftime. Music has been part of the township's school curriculum since 1910.

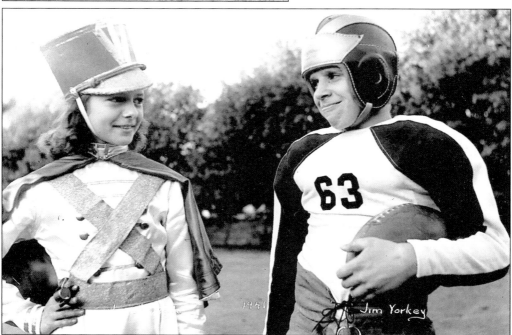

Majorette Jean Meyle and football player Jim Yorkey exchange admiring glances in this Oakmont School photograph taken in 1941. Haverford Township School District has had a long tradition of team sports and extracurricular activities for its students. The sense of school pride starts at the grade school level and culminates with the strong bonds of its past alumni.

With their safety badges securely strapped over their shoulders, members of Oakmont School's Safety Patrol stand at attention on school steps in this 1932 photograph. The Safety Patrol Program was sponsored by the Keystone Automobile Club, which taught children how to maintain a safe school environment in and around the school property.

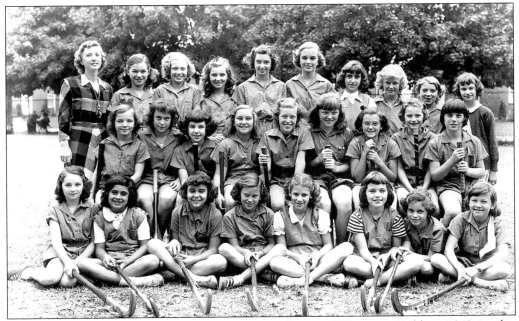

Girls from Manoa School's field hockey team gather at Williamson Field in 1949 in this photograph lent to us by longtime resident Betty Hammett Lipton. Thanks to attitude changes toward girls in sports, the number of girls going out for sports, as well as the variety of team sports offered for girls, has grown immensely over the years.

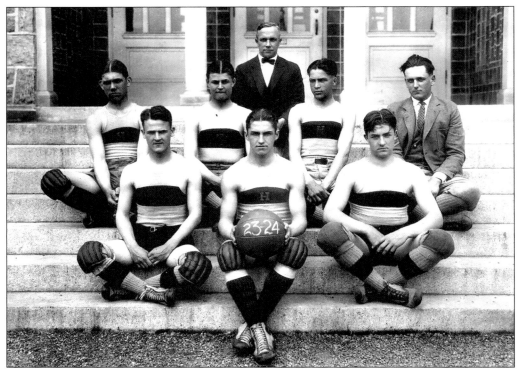

Members of Haverford High School's 1923–1924 basketball team pose outside the main entrance of the high school, now the administration building. Mr. Ellis, the team coach, sits in the back row. The man wearing a three-piece suit is Bill Gettz. There is no margin for foul or injury with such a small team.

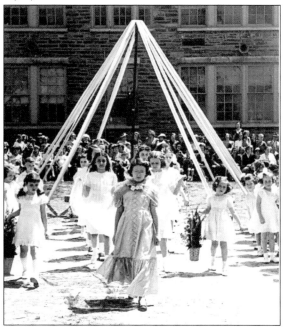

This photograph from Dr. Blair Daniel's collection cannot convey the elaborate spectacle of the May Day ceremonies held at the Chestnutwold School in 1947. May Day, a festival originating in the English countryside before the Middle Ages, was celebrated by these students choosing and crowning a new May Queen and taking part in various other activities, including the Maypole Dance, the most popular event.

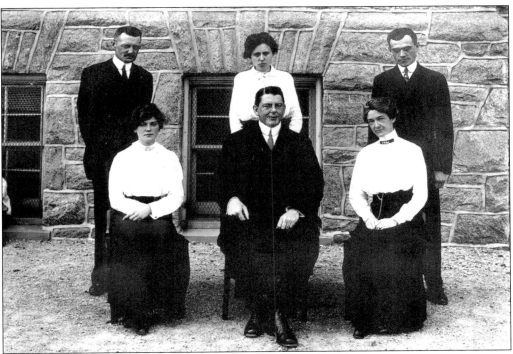

The high school faculty poses outside the Oakmont School in 1914. From left to right are the following: (front row) an unidentified teacher, principal Joseph W. Huff, and Elizabeth Welch; (back row) A. Reist Rutt, an unidentified teacher, and Ammon Kirschner. In 1908, Huff arrived in Haverford Township as the supervising principal and sole teacher of the high school located at Llanerch. He was named the school district's first superintendent in 1920.

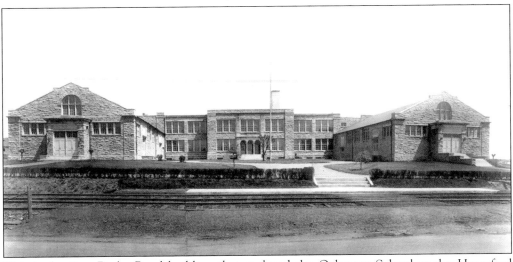

This is the East Darby Road building that replaced the Oakmont School as the Haverford Senior High School from 1923 until 1956. The building was enlarged in 1926 to include the junior high school students. The building now houses the school district's administrative offices and part of the middle school classrooms.

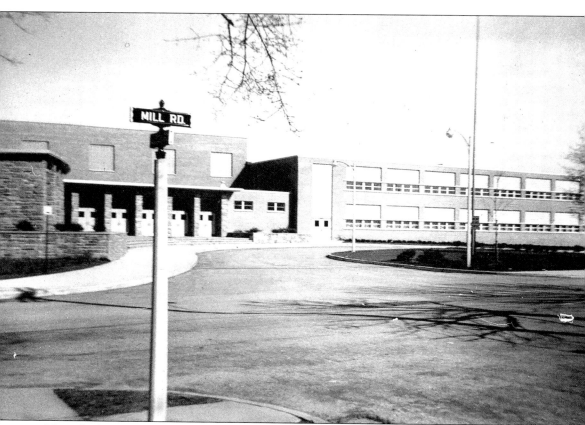

Haverford Senior High School, on Mill and Leedom Roads, was built in 1956 on the former site of the Brookline Square Club. New school construction had been suspended for 30 years. The postwar baby boom brought on a rapid expansion of school population, and four new schools were built. First was the Lynnewood School in 1951, then the Chatham Park School in 1955, the high school in 1956, and the Coopertown School in 1958.

Five

PASTIMES

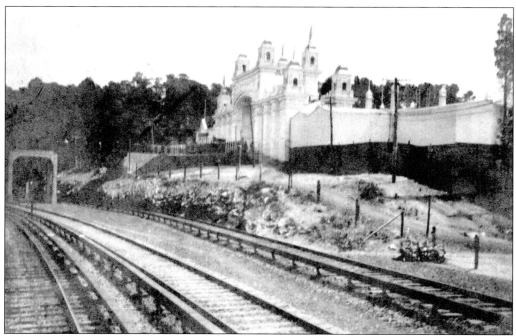

What looks like a mirage is actually the Beechwood Amusement Park. Nestled on the hillside along the Powder Mill Valley, the 20-acre amusement park was built by the Philadelphia and Western in 1907 to offer its riders an entertaining destination in the country. Poor management and bad weather were blamed for the park's demise. In 1909, the Philadelphia and Western Railway Company abandoned the park. (Courtesy of the Keith Lockhart Historical Collection.)

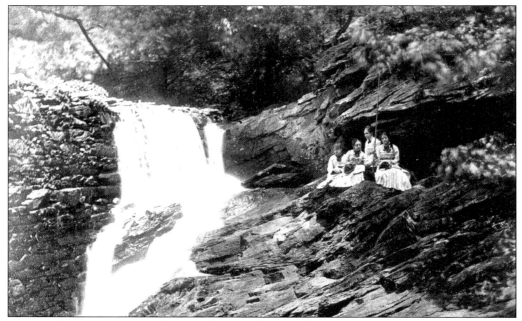

In this 1901 photograph attributed to Dr. John W. Eckfeldt, four young ladies take time out from gathering flowers to rest alongside the falls at Powder Mill. This area, nestled along the banks of Cobbs Creek, was a favorite hiking trail and common destination for picnickers, landscape artists, and botanists. Unfortunately, in the summer of 1909, a remarkably high freshet, or severe summer rainstorm, caused the creek to swell and destroyed the picturesque falls.

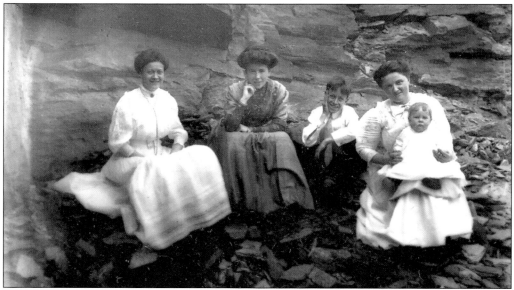

This family is posing for pictures at the bottom of a quarry. Several local quarries were excavated to produce the stone for most of the homes built in the community. The last active quarry, located on Township Line Road near Lansdowne Avenue, was Llanerch Quarry. After years of underground streams seeping into the cavernous hole, the quarry was closed and is in the process of being filled in.

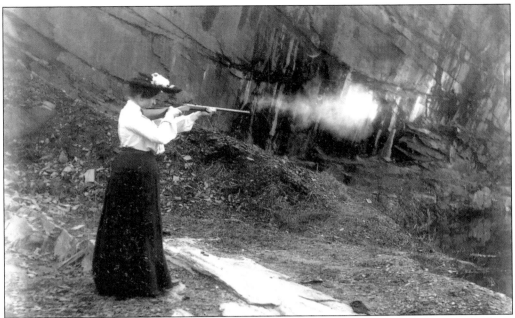

No, this is not a photograph of Annie Oakley. This young lady is practicing shooting a rifle in the quarry. If you look closely, you can see the smoke rising from the barrel of the sharpshooter's rifle. As with the previous photograph, Wilbur Hall carried his camera down into the depths of the quarry to catch a glimpse of what his family and friends did for entertainment.

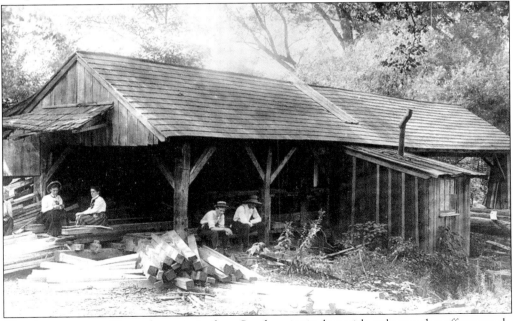

This does not seem like a pleasant site for a Sunday picnic, but with only one day off per week, these sawmill workers and lady friends spend a peaceful Sunday afternoon at the Leedom Saw Mill. This photograph, credited to Dr. John Eckfeldt, shows the rough working conditions and meager amenities available to the working class.

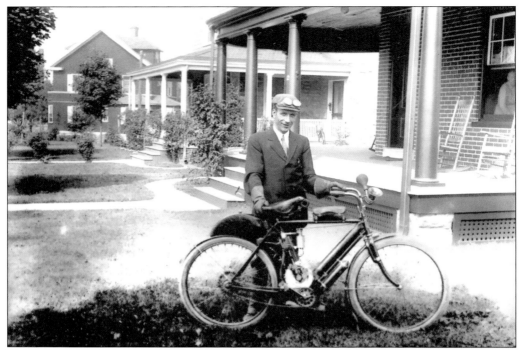

This gentleman is posing with his new motorized bicycle in front of Wilbur Hall's house on Tenby Road in the Llanerch section of Haverford Township. Notice the sparse plantings and height of the tree in the background. Most of the houses in this section of Llanerch were built in the early 1900s.

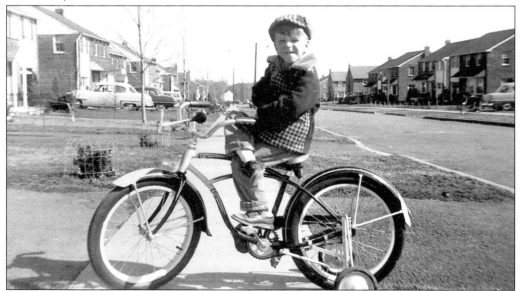

This young fellow demonstrates pride and dexterity—notice the crossed legs and folded arms—on his brand-new bicycle. This 1953 photograph shows Jeff Evins posing in front of his house on Harrington Road in the new post–World War II housing development in the Manoa section of Haverford Township.

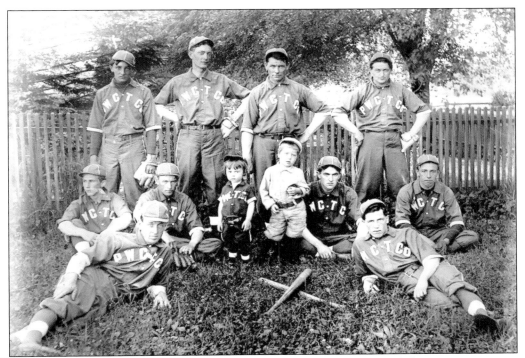

The Philadelphia and West Chester Traction Company baseball team and their two mascots, or bat boys, pose for this photograph taken by Wilbur Hall. The turn of the century had produced some dramatic changes in how management treated their employees. These included shorter workdays, better pay, improved working conditions, and even company-sponsored teams.

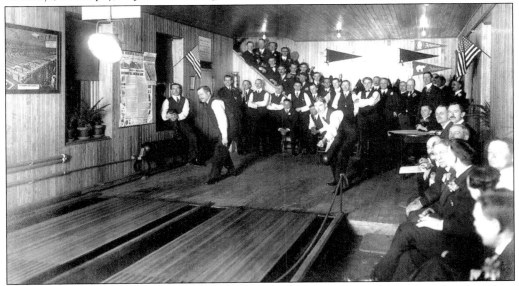

Here the Philadelphia and West Chester Traction Company competes against the American League champion Philadelphia Athletics. The manager of the Athletics, Connie Mack (in the right lane), is playing against A. Merritt Taylor, president of the traction company. This contest marked the opening of the traction company's employees' bowling alley in Llanerch in 1912.

We cannot be sure where this house is located, but Wilbur Hall took the photograph. It is a lovely example of the kind of relaxation an older woman would find appealing in the early 1900s.

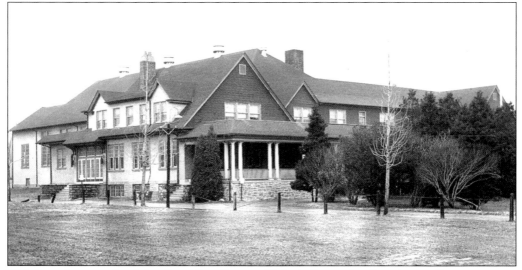

This is a photograph of the Brookline Square Club, built on the Pennington Farm property. Dedicated in 1924, the country club had an 18-hole golf course and swimming pool, which it sold off in 1927 to the developers of Woodmere Park. After the high school was built, the clubhouse was torn down to make room for the athletic fields.

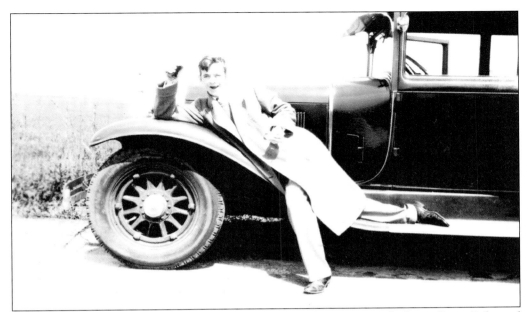

In this photograph, Llanerch native William Prichard enjoys a refreshing Coca-Cola and sandwich while stretched out on the running board of his family's new 1929 LaSalle. Road trips were a common diversion in the early days of motorized transportation. (Courtesy of the Roger T. Prichard Collection.)

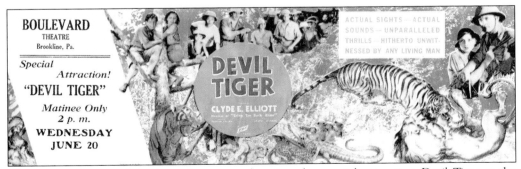

This rare and unusual-sized movie poster advertises the special attraction *Devil Tiger* at the Brookline Theatre. The Boulevard Theatre, as it was once called, appears in the first *Haverford Township Business and Professional Directory*, dated 1934, as "the *Only* Theatre in Haverford Township." The address is given as "near trolley station on Brookline Blvd., Brookline."

This 1907 postcard shows the original clubhouse for the first country club on the property now known as the Llanerch Country Club. Established in 1901, it was first called the Delaware County Country Club. Several changes occurred over the years, the worst being a 1918 fire that destroyed the clubhouse and killed two live-in employees.

Up from the ashes, the present-day clubhouse of the Llanerch Country Club was begun immediately after the disastrous fire. In 1919, Thomas Fitzgerald was granted a charter for the Llanerch Country Club and was named president. The new clubhouse was opened in June 1920. The redesigned course reopened on Labor Day 1924. Llanerch is the only remaining country club in Haverford Township and one of the three remaining golf courses.

Here, Haverford College's top men's tennis team players, Diehl Mateer and James Schnaars, introduce themselves to Jane Austin, the No. 1 player from University of Pennsylvania and Cynwyd Club and Sue Peterson, the No. 2 player at Cynwyd Club before their separate men's and ladies' singles matches. The Penfield Civic Association sponsored these and other activities at the dedication of the Powder Mill Park and Grange Playfield held on May 24, 1947.

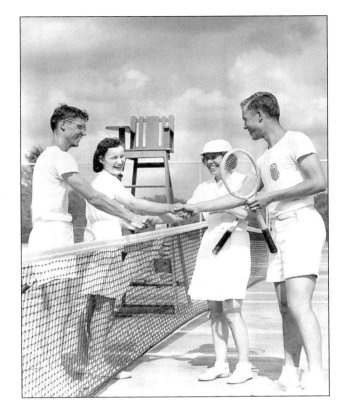

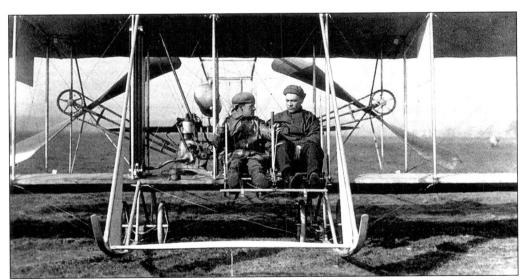

Grover C. Bergdoll, on the right, and his brother Erwin prepare for takeoff from the Eagle Aviation Field in this 1911–1912 photograph. Perhaps it was the thrill of danger that led him to flying, racecar driving, and refusing to serve in World War I. He eluded capture for 20 years until he was arrested, tried, convicted, jailed, and finally released in 1944. (Courtesy of the Chester County Historical Society.)

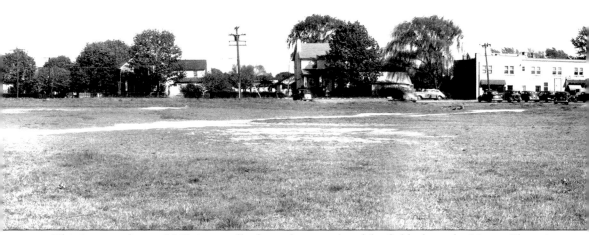

This image, taken c. 1940, is actually three photographs of the field where the Manoa Shopping Center now stands. It was once home to the Eagle Aviation Field. Grover Cleveland Bergdoll, grandson of Louis Bergdoll, the founder of the Bergdoll Brewery in Philadelphia, flew his Wright "B" Flyer out of this airfield. Later, the low, more modern buildings were constructed by George Shadel and owned by William Bernhard. The large, gabled-roof building is identified

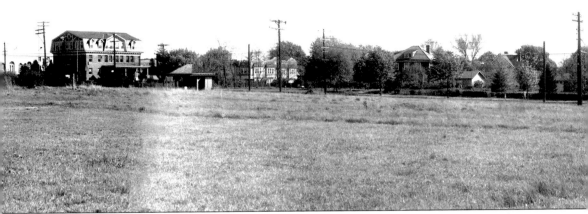

as the Eagle Hotel. Toward the center of the picture, the building with the arched windows is certainly the Club Del Rio. Quieter pastimes like Class D baseball were later enjoyed on the field before its conversion to a shopping center in the early 1950s. (Courtesy of the Thomas Massey House Collection.)

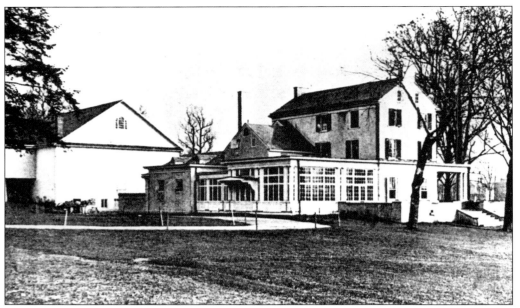

This is a 1912 photograph of the clubhouse at the Merion Golf Course. With the popularity of golf in the 1890s, some members of the Merion Cricket Club formed a committee to plan for a golf course. An 18-hole course was completed by 1896. The Merion Golf Club was officially organized as its own entity 1942. (Courtesy of the Merion Golf Club.)

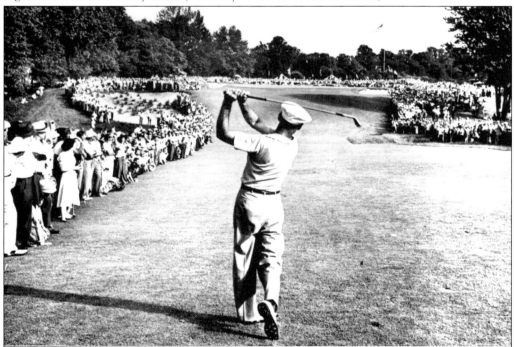

Ben Hogan, shown in a famous photograph by Hy Peskin, is hitting a one iron to the Merion Golf Club's 18th green in the 1950 USGA's Open Championship. It was necessary to have an 18-hole playoff the following day, which he won. (Courtesy of the Merion Golf Club.)

Dorothy Germain Porter poses with her baby daughter, Nancy Dorothy Porter, and the trophy she won at the 1949 USGA Women's Amateur Golf Tournament, held at the Merion Golf Club. A longtime member of the Llanerch Country Club, Porter had trained under golf pro Marty Lyons from the time she was a young girl. (Courtesy of the Merion Golf Club.)

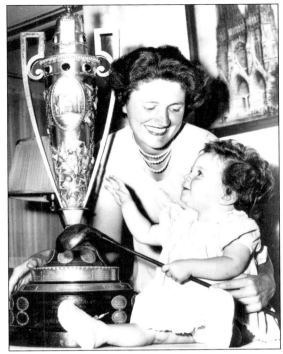

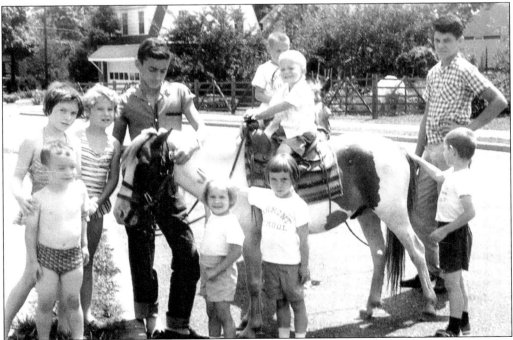

The children on Thompson Avenue in the Oakmont section of Haverford Township gather around to take pony rides in this 1962 photograph. The suburbs might seem pretty countrified, but still many children had never been that close to a large animal. For 25¢, you could hop on and get a ride down to the corner and back.

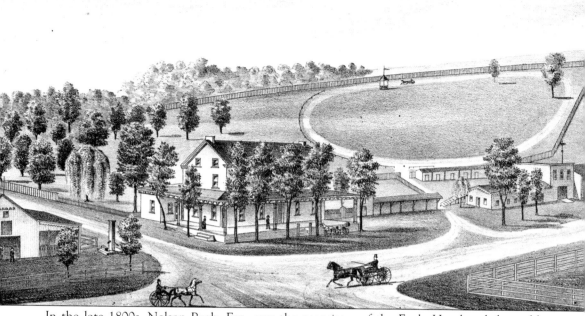

In the late 1800s, Nelson Pugh, Esq., was the proprietor of the Eagle Hotel and the stables, shops, and racetrack that encompassed the area now known as Manoa. This photograph, taken from an 1875 atlas of Delaware County, may not be to scale, but it does support the stories passed down that such a facility did exist. In Henry Graham Ashmead's *History of Delaware County, Pennsylvania*, published in 1884, it was reported that in 1875, Roland J. Pugh was approved for a tavern license, and in that same year the privilege was transferred to Nelson Pugh. West Chester Pike was indeed an important thoroughfare between Philadelphia and West Chester. During that time, Eagle Road was a direct link between Darby Township and Norristown. It was truly an ideal location for so many forms of entertainment and relaxation.

Six

BUSINESS
ESTABLISHMENTS

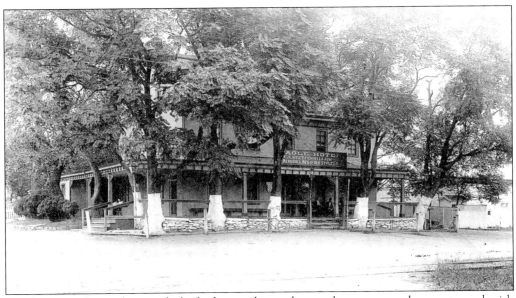

The bumpy ride on the wood-planked turnpike made travelers weary and eager to replenish themselves at taverns. The trees of the Eagle Hotel became an easily recognizable landmark. On the sign is the name Bergdoll, who owned the property on the northwest corner. The Bergdolls used their open land as a private airfield. That property, now known as Manoa Shopping Center, was used by the air force during World War II. (Courtesy of the Hagley Museum and Library.)

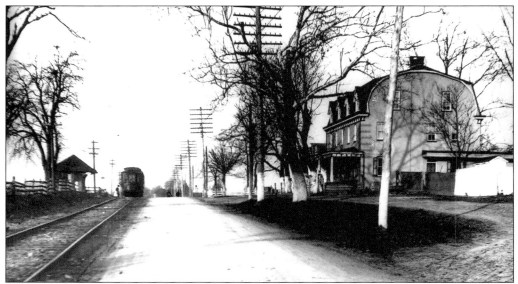

Established in 1814, the Spread Eagle Tavern, was located on the northeast corner of Eagle Road and West Chester Pike. Original owner and turnpike shareholder James P. Afflick profited very well from this major stop on the West Chester Turnpike. William Bittle operated the Haverford post office at this location from 1841 until it moved to the Black Bear Tavern in 1847. (Courtesy of the Thomas Massey House Collection.)

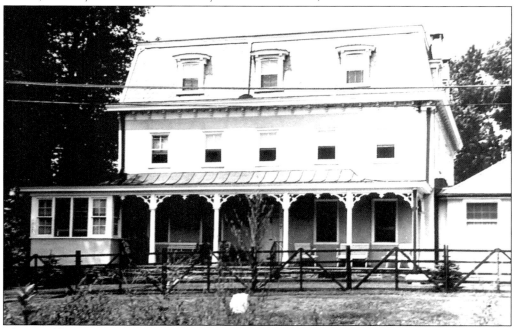

The Stackhouse Tavern, built in 1820 and owned by William Stackhouse, is located between Lawrence and Eagle Roads on West Chester Pike. The tavern is believed to have been part of the Underground Railroad. In the 1860s, James Erskine renamed it the Black Bear Inn. The Haverford post office was located here from 1847 until the early 1900s. (Courtesy of the Thomas Massey House Collection.)

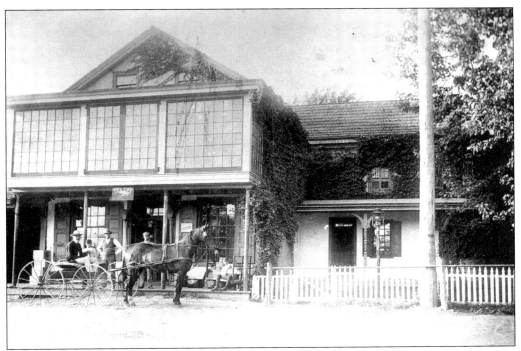

This 1894 photograph shows Samuel Moore's general store, at the northeast corner of Manoa Road and West Chester Pike. The gentleman with his hands on hips is Samuel Moore, proprietor and postmaster since 1833. Moore began calling his establishment the Manoa Store, and this post office name was adopted.

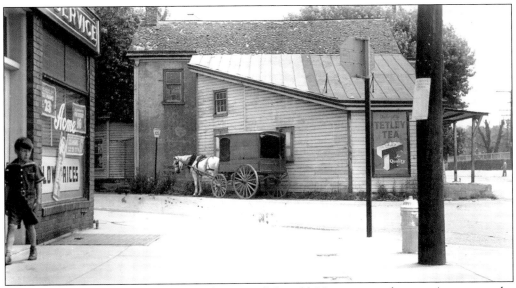

This undated photographs shows a side view of the old Moore general store. A note on the back explains that the horse and wagon belong to the Savage boys, who collected garbage to feed pigs. Their family's farm later became West Gate Hills. The newer building on the left is an Acme store. (Courtesy of the Thomas Massey House Collection.)

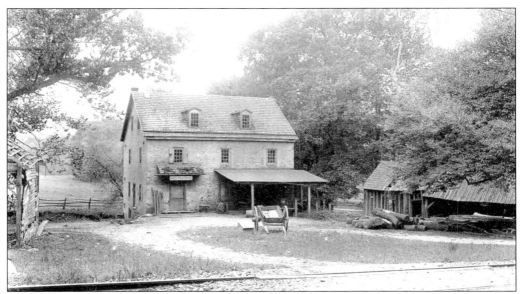

Shown in this 1900 photograph is the Adele post office, established in 1892 at the gristmill on Darby Creek. August B. Leedom was proprietor and postmaster from 1892 to 1901, when the post office was shut down. The post office was named after the daughter of Congressman John B. Robinson, who secured the post office's location on Old West Chester Pike. (Courtesy of the Hagley Museum and Library.)

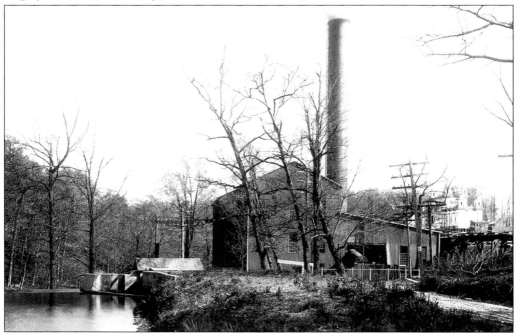

This power plant for the Philadelphia and Western Railway Company was located along Karakung Creek, now known as Cobbs Creek. The plant was situated on the site of the dam built for the old Dickinson Mill. Seen in the distance of this 1907 photograph is the grand entrance to the newly opened Beechwood Amusement Park, located at the Beechwood Station.

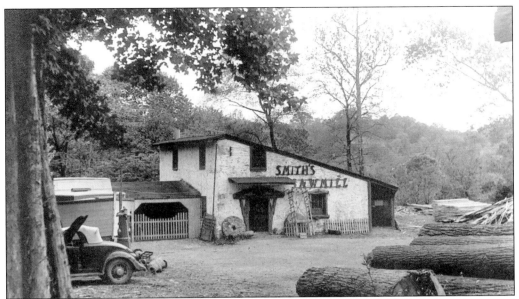

This photograph was taken on the 1941 pilgrimage of the Haverford Township Historical Society. The first owner, Humphrey Ellis, operated a wool-processing mill at the site along Darby Creek, on Old West Chester Pike near Lawrence Road. In 1807, the Lawrence family ran it as a gristmill. In the 1930s, Robert H. Smith converted the operation into a sawmill. The mill operated continuously from the 1700s until 1987.

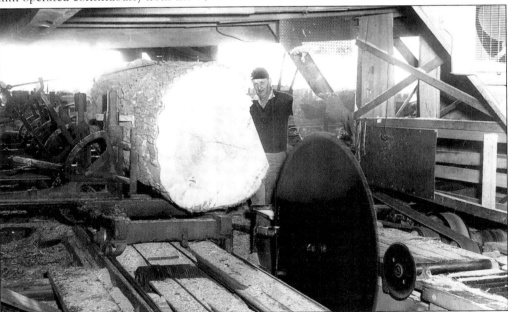

Smith's Sawmill provided wood products for World War II, with wood donated from local residents' properties. This 1958 photograph shows Bob McGrath operating the lumber-splitting machinery. He purchased the mill in the 1980s and continued to run the sawmill until 1987. The Haverford Township Historical Society moved the Lawrence Cabin, located near the mill, and the 500-pound gristmill grinding stone to Powder Mill Valley Park in 1961.

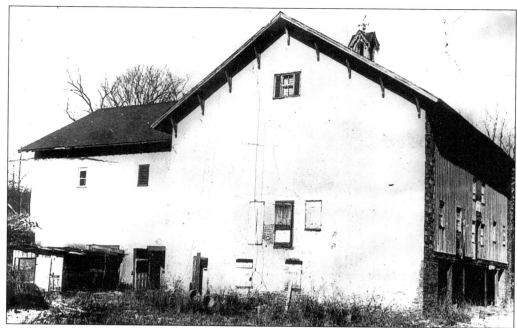

Seen here is the dairy barn at the Grange Estate as it appeared c. 1940. The three-and-a-half-story, stucco-covered, fieldstone-and-clapboard-sided barn (dating from 1863) was converted to the St. James Church in 1948. The postwar housing community of Chatham Village was built on land once belonging to the Grange. The photograph below, from 1933, shows the dairymen preparing to make their deliveries. The advertisement on the canvas flap of the truck confidently advertises that the pasteurized milk has been tuberculin tested. Stories are still told about the cows having to be herded off busy Route 1 and returned to the Grange Estate.

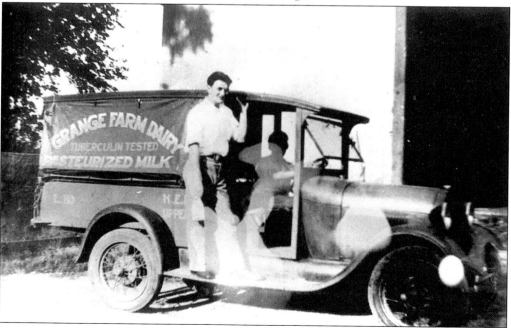

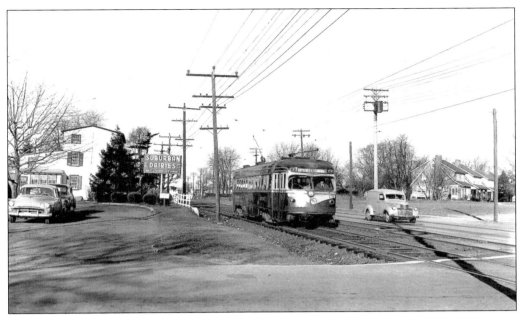

Suburban Dairies once stood where the American Catholic War Veterans Hall now stands. The sign seen in this early-1950s photograph reads, "Mrs. J. Gormley, Proprietor." Joseph T. Gormley was listed as proprietor in the 1939 program for the Benefit of the Police Pension Fund. In that advertisement, it states, "We serve all the schools in Haverford Township." According to their son's obituary in 2003, Joseph and Mary Nunan Gormley founded the dairy in 1912.

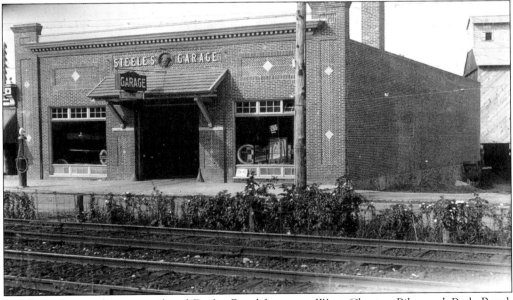

In Llanerch, on the west side of Darby Road between West Chester Pike and Park Road, Steele's Garage and other stores have been present since the 1920s. Steele's looks the same, but the gasoline pump has long been removed. Behind the garage is the Coal Yard Building of the Red Arrow trolley. Additional Red Arrow buildings were located on the south side of West Chester Pike, just west of Darby Road.

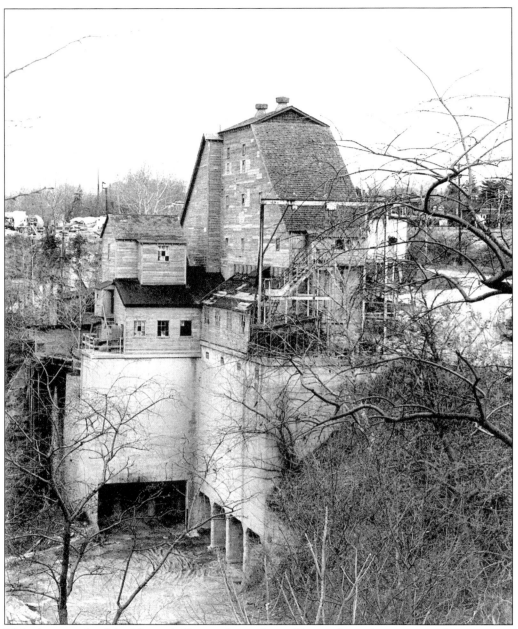

This photograph of the Llanerch Quarry shows the striking and massive structure that was once considered an eyesore by some and the object of curiosity and majesty to others. Opened in 1924 by Vincent DiFrancesco, and later operated by Joseph DiFrancesco, the Llanerch Quarry produced crushed stone. The quarry is located on the west side of Township Line Road, south of the West Chester Pike intersection behind the Kohl's department store. In 1973, one portion of a wall of the quarry collapsed, allowing Naylor's Run Creek and a sewer line to flood the quarry. The collapsed wall and water filled the quarry, approximately 30 feet deep, putting in question the safety of the surrounding homes and roadway. The quarry was closed, and the site is now being used as a landfill. (Courtesy of the News of Delaware County.)

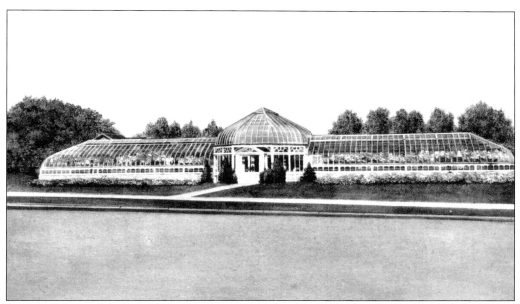

In 1927, Schearer's Greenhouses opened on the north side of Darby Road near the northeast corner of Manoa Road. The buildings were originally constructed in 1905 on the Cyrus H.K. Curtis Estate near Wyncote. In 1961, the greenhouses were purchased by Henry Hayes, a florist, who relocated them to his place in Media. (Courtesy of the Keith Lockhart Historical Collection.)

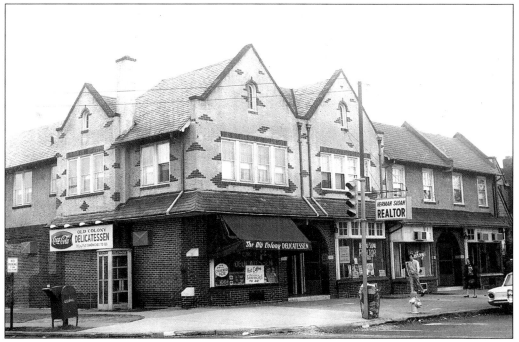

In an effort to refurbish and revitalize the business districts, photographs of local stores were taken in 1966 as part of the Facelift Havertown Project. Many of these photographs currently hang in local stores and restaurants. Havertown Pizza has occupied the southeast corner of Darby and Manoa Roads, previously the home of the Old Colony Delicatessen, for the last 20 years.

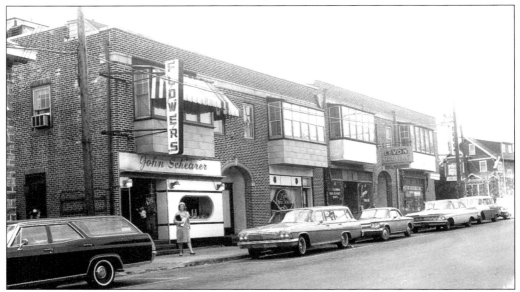

This 1966 photograph shows the southeast corner of shops on Brookline Boulevard. The young soldier, apparently home on leave from the war in Vietnam, is carrying a potted hyacinth, and the young woman is wearing a corsage just purchased at the John Schearer flower shop. It looks like Chevys were very popular in those days.

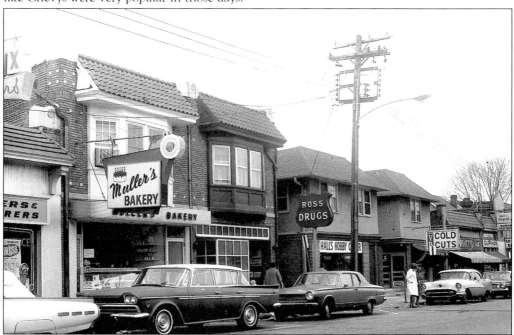

Another 1966 photograph of Brookline Boulevard takes us across the street on the north side of the block. Every child who could ride a bike would find their way to Muller's Bakery for cookies or cupcakes. Ross Drugs, with its dark wood cases and huge apothecary bottles filled with tinted water, epitomized the neighborhood pharmacy. Hall's Hobby Center had the best crafts. Remember making tile trivets?

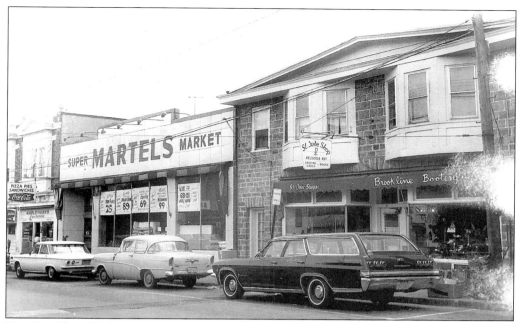

The Brookline Boulevard Business District, pictured here in 1966, was built during the 1920s. Martel's was down the street from the Shearer flower shop and was considered, at the time, to be a large grocery store. The St. Jude Shop, once a single storefront, now stretches from what was the shoe store down to the far end of Martel's.

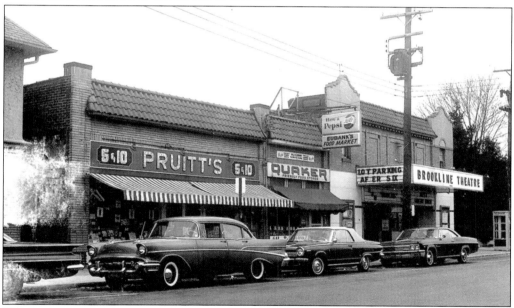

When this 1966 photograph was taken, the Brookline Theatre was owned by William Reese. Although the theater was small, the owners were able to run the latest releases. The neighborhood theater became obsolete after large multiplex theaters sprang up in the late 1970s. The Brookline survived for a short while as a second-run theater. Now it is home to a gym where the walls are painted with movie nostalgia in memory of the old theater.

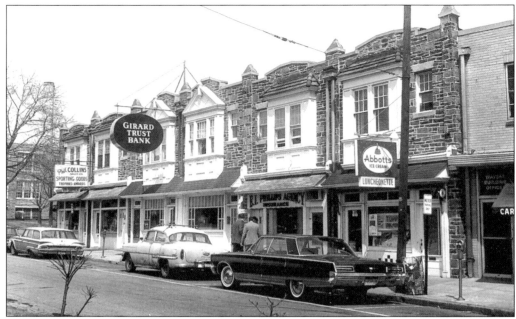

Unlike the new megabanks, the Girard Trust Bank (now Citizens Bank) just sits in the middle of the block rather innocuously in this 1966 photograph. It was later relocated to the corner where a miniature golf course once stood. Out of camera range, to the right of the luncheonette, was a small card shop where ladies gathered in the back to paint and fire-glaze china.

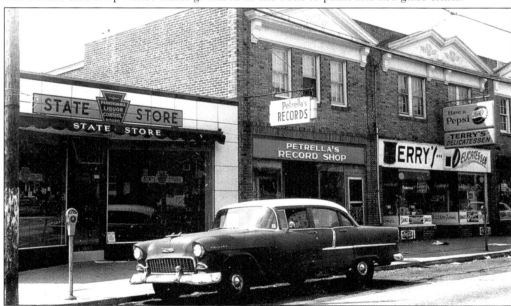

South Ardmore got its name from the trolley stop at Darby Road and Benedict Avenue. In the 1960s, students walking home from the junior or senior high could stop in at Petrella's Record Shop and listen to the newest records before having to buy them. Photographs of Mr. Petrella with local performers hung on the walls. At Terry's, students could reach into the ice chest and get a Popsicle to cool them all the way home.

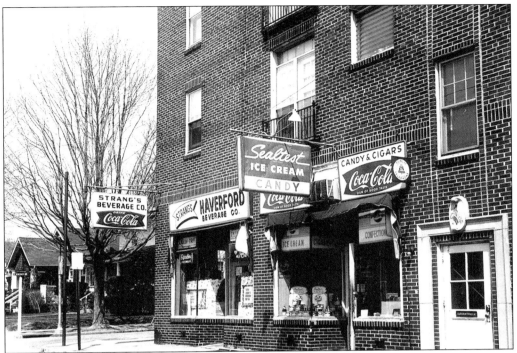

At the corners of Darby Road and East Benedict Avenue stands the Southmore Court. The two businesses served the community for many years. Strang's Beverage Company advertises local favorites Ballantine and Reading beer while the candy store next door advertises another locally made product, Sealtest ice cream.

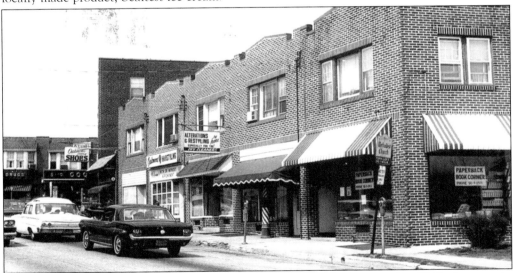

The stores located on West Darby Road have changed very little since this 1966 photograph. Their architectural style is two-bay, two-story parapet fronts with flat built-up roofs behind. Sometime between 1913 and 1925, these and the other stores that make up the Oakmont Shopping District were built to accommodate local residents and Red Arrow trolley passengers. Who knew then that the Ford Mustang would become a classic?

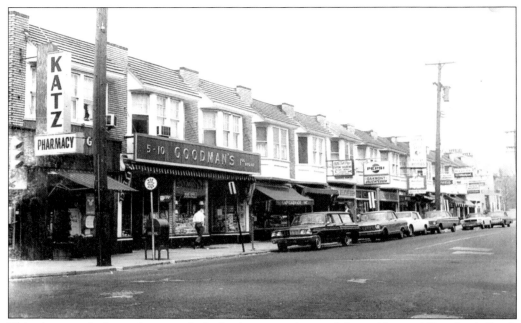

This photograph shows the stores built for the convenience of the residents of Grassland, South Ardmore, and Oakmont. Katz Pharmacy, once Oakmont Pharmacy, has been a landmark for two generations. One can recall being able to buy anything needed at Goodman's five-and-dime just as long as one of the Goodmans could find it. And who could forget the thrill of getting their first bike from the Oakmont Cycle Shop?

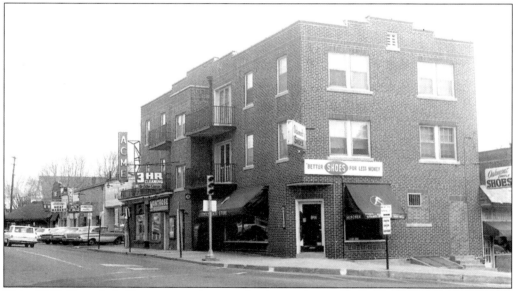

This 1966 Face Lift Havertown photograph shows the south side of Eagle Road at the intersection of Darby Road. At the corner, this three-story apartment building houses Oakmont Shoes, Montrose Dry Cleaners, and a barbershop on its first floor. By today's standards, a very small Acme store occupies the middle of the block where Mape's True Value is now located. Notice the diagonal parking up the street.

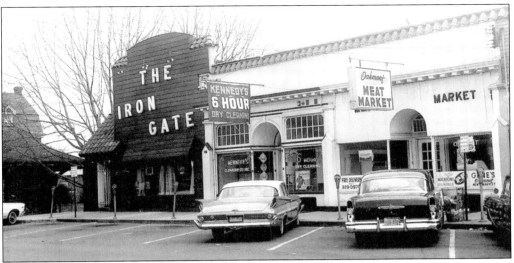

The building at the far end of the block once housed the Oakmont National Bank. The Depression may have shut down the bank, but the owners of the Oakmont Pub use the old vault to display some vintage photographs inside. The bank's original arched window has been exposed, and the iron gate at the entrance still stands as a reminder of the old Iron Gate tavern.

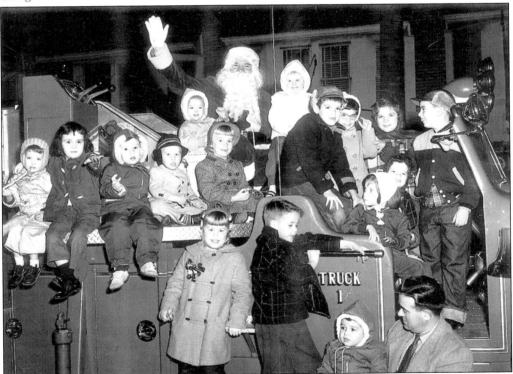

Santa Claus greets the children and Christmas shoppers in the Oakmont Shopping District in this 1957 photograph. Santa, portrayed by Frank C. Murta, local plumber and heating contractor, rode on top of the Oakmont Fire Company No. 1 fire truck onto Eagle Road to switch on the holiday lights. The Oakmont Business Association sponsored the event.

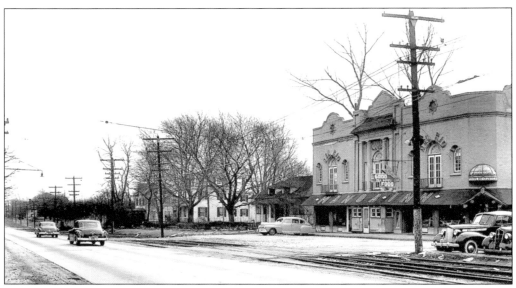

Photographer Bob Fox took this 1952 photograph of the Manoa Inn and Club Del Rio, located at the southwest corner of West Chester Pike and Eagle Road. Opened by Bill Boyd in 1927, the Club Del Rio was a Spanish hacienda-style nightclub, operating as a speakeasy during Prohibition. A 1933 program for the Manoa Fire Company Minstrel Show and Dance, held at the club, describes the establishment as "the most beautiful Club in the Country."

Edward P. Fenimore, a chemical engineer, founded the Philadelphia Chewing Gum Corporation, producers of Swell bubblegum. Fenimore opened the Havertown plant in 1948. The location was originally chosen for its proximity to the Pennsylvania Columbia line, on the south side of Eagle Road near Lawrence Road. For decades, children enjoyed the wonderful smell while passing the factory.

Seven

HOMES OF
PROMINENT PEOPLE

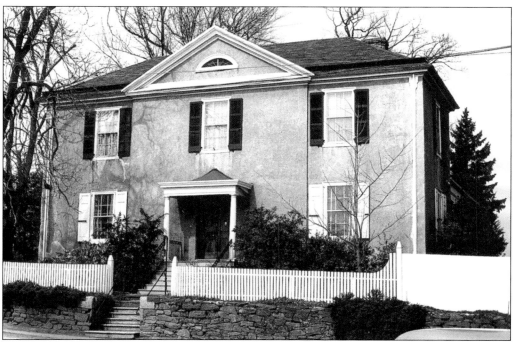

Pont Reading, located on Haverford Road, was named for the Humphrey homestead, Reading Pont in Wales. The original log house was built on a land grant from William Penn to Daniel Humphreys in 1683. The Humphreys were active in the Society of Friends and in community affairs. Joshua Humphreys, first marine architect of the American navy and the designer of the frigate "Old Ironsides," built this front addition in 1813. He spent the last 30 years of his life at Pont Reading.

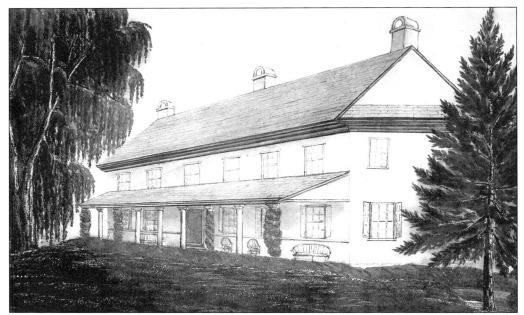

The Grange, originally a land grant from William Penn to Welsh Quaker Henry Lewis, was named Maen Coch in 1682 after Lewis's home in Pembrokshire, Wales. Ownership of the 500-acre estate passed to son Henry Lewis in 1705. The property was sold in 1749 to Capt. John Wilcox, a Philadelphia merchant, and his wife, Elizabeth, who erected a Georgian stone mansion and named it Clifton Hall.

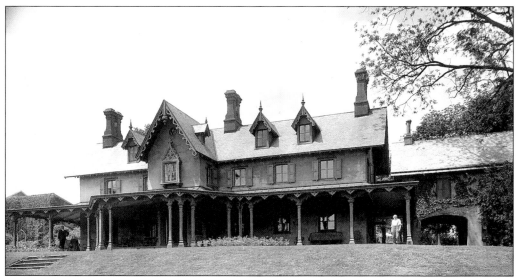

The Grange was sold in 1761 to Clemantina and Charles Cruikshank. Dr. George Smith writes that Cruikshank named his new home the Grange or Grange Farm. There is a tradition that Cruikshank's son-in-law John Ross named the Grange for Lafayette's home, La Grange, in France. Cruikshank is also credited with increasing the acreage, adding the landscaping, terraced walks, and the necessary. The Victorian mansion and porte-cochere wing are pictured here in 1895.

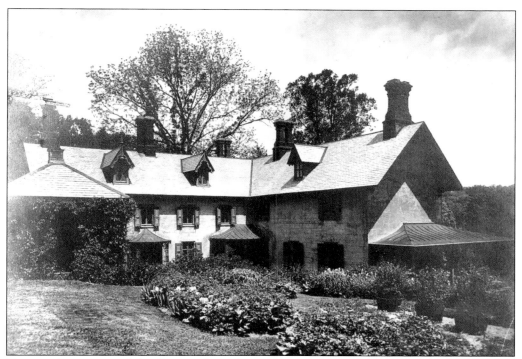

Here we have view of the Grange from the garden in 1900. Charles Cruikshank's daughter Clemantina married John Ross, a prominent merchant who helped to finance the Revolution. He was the owner from 1782 to 1818. George Washington writes in his diary of dining with Ross in "Chester County" in 1787. After Ross's sudden death, the owners were Manuel Eyre, Dennis Kelly, and in 1850, John Ashhurst, Eyre's son-in-law.

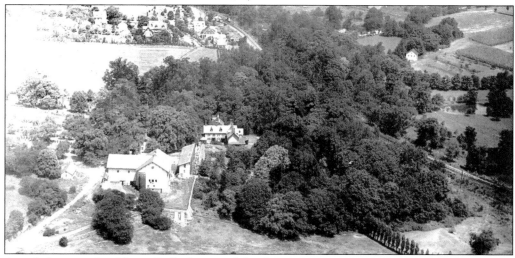

Aerial photographer Victor Dallin's view of the Grange in 1920 captures the original tree-lined entrance, barns, gardens, outbuildings, and fields. In 1913, Benjamin and Margaret Hoffman purchased the Grange Estate, which by then encompassed only 86 acres. During the Depression, parcels of land were sold, reducing the estate to 9.9 acres. These parcels include the ground on which Chatham Village, the Grange Field, and St. James Church were built.

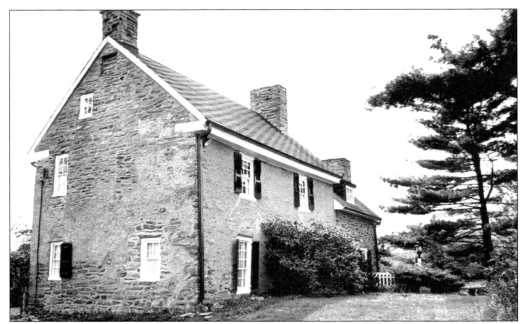

This Robin Lane home on the former Atwater Kent property is seen in 1967. The core of this home is a small 1740 one-and-a-half-story house with a two-and-a-half-story addition. Many original interior features were respected in restoration work. Note the empty niche at the roof peak, where a date stone may have been.

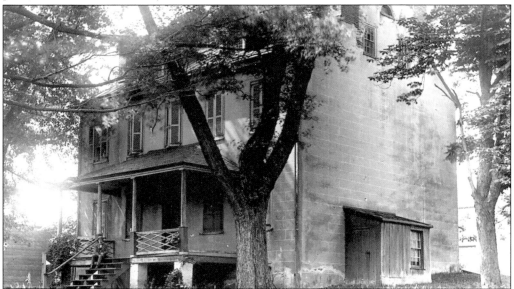

Purchased in 1794 for the summer home of Adam Eckfeldt, the Eckfeldt Farm, Greenwood, extended from Manoa and Earlington Roads to City Line Avenue and Darby Road. President Madison appointed Adam Eckfeldt to the office of chief coiner of the U.S. Mint in Philadelphia. Both Adam's son Jacob Reese Eckfeldt and grandson, also Jacob, were assayers of the mint. Grandson Dr. John Eckfeldt, an early resident of Brookline, wrote *Cobbs Creek in the Days of the Old Powder Mill.*

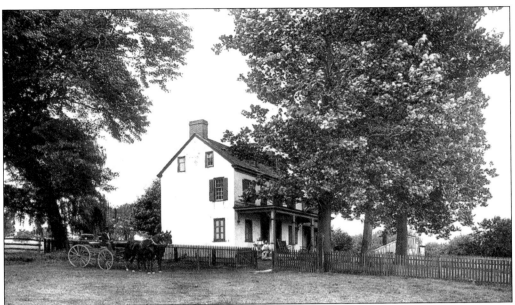

Joseph Leedom's house on Center Road *c.* 1910 was part of Lewis David's property. Joseph Bond Leedom married Elisha Worrell's daughter Mary and thus acquired the Haverford New Mill, which he operated as a grist- and sawmill in 1829 on Darby Creek. His grandsons William and John farmed the land and may be the two men sitting on the porch. The man driving the team is unidentified. (Courtesy of the Sellers Memorial Library.)

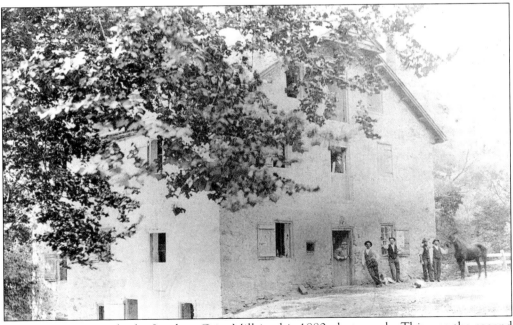

Workers pause outside the Leedom Grist Mill in this 1880 photograph. This was the second mill building. Richard Hayes built the first mill, Haverford New Mill, on Darby Creek in 1707. (Courtesy of the Thomas Massey House Collection.)

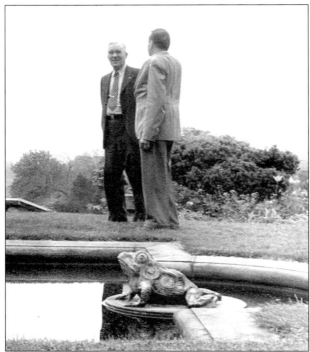

Participating in the 1939 historical society pilgrimage, Lewis C. Street Jr. and Richard Wingate Lloyd stand above the retaining wall, or haha, for the sheep that grazed freely in the meadow at Allgates. The large frog that appears to be preparing to jump from the lily pad is actually an ornament in the reflecting pool. Today the homes of the Allgates Estate would be seen from this vantage point.

Architect Wilson Eyre designed Allgates in 1910 for banker Horatio Gates Lloyd Sr. Lloyd served as township commissioner in the fourth ward, and his son donated the library building in 1937. The 55-room mansion, constructed of New Jersey sandstone and covered with stucco, is located on Coopertown Road. The estate featured a formal entrance with a circular drive, gazeboes, tennis court, Mercer tiles, lily pond, and the famous Iris Bowl, with its hundreds of varieties.

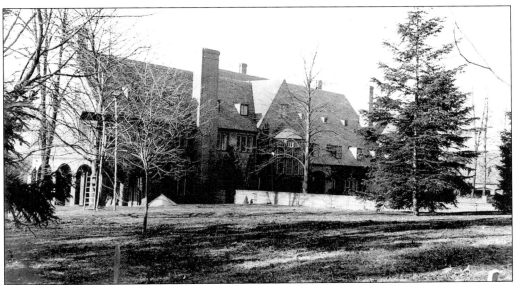

Charles Willing designed Linden, a home on Darby Road at College Avenue, for H. Gates Lloyd Jr. Built in 1930 on 76 acres abutting his father's Allgates Estate, the 14-room brick mansion in the Tudor style has only two fireplaces, compared with one in every room at Allgates. The home's window sills are of marble or stone. Sold to the Marriott Corporation, it is now part of the Quadrangle Retirement Community.

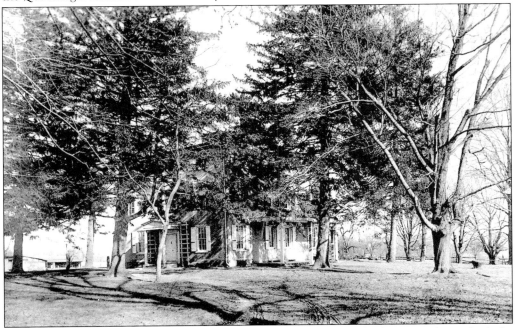

The Sellers family of Upper Darby owned Liddonfield Farm. The homestead was built by Abraham Liddon Pennock and was located just north of Harrington Road on the east side of Eagle Road. The tenant house was built of brick imported from England. The Liddonfield Farm was located on the property where the chewing gum factory and the Manoa Presbyterian Church are today.

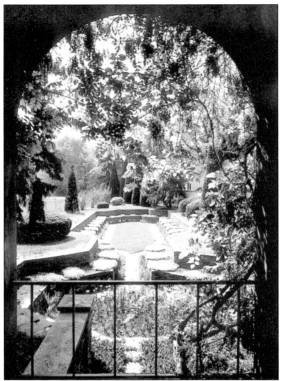

William Maul Measey planned the main approach to Casa al Sole through beautifully landscaped grounds. The garden was originally planted with 35 varieties of deciduous and evergreen trees and carefully sculpted shrubbery to make the garden beautiful in all seasons. The sunken gardens, seen through the archway in this photograph by Neville Ehmann, are south of the house, parallel with Darby Road and bordered by the Merion Golf Course.

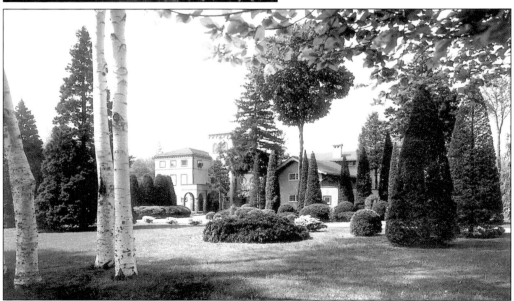

Casa al Sole, at Darby Road and Ardmore Avenue, incorporates the old structures of a 19th-century stone farmhouse and the 1836 Coreze post office and popular country store. Work on this Italian-style villa, first owned and designed by wealthy and reclusive Philadelphia lawyer William Maul Measey, was started in 1913 and completed in 1922. The third floor, stairwell, tower, and the hyphen between the buildings were later additions.

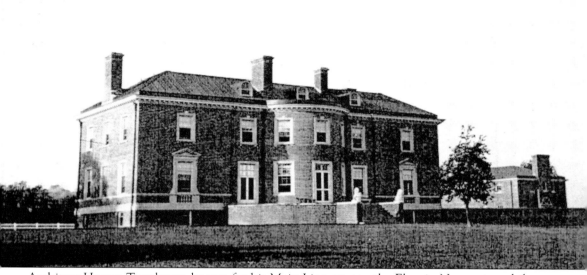

Architect Horace Trumbauer, known for his Main Line estates, the Elms in Newport, and the Free Library of Philadelphia, planned Craig Hall, a mansion in the English Georgian style, in 1925. This photograph shows the east facade of the home, located on Coopertown Road. For mysterious reasons, the entire third floor was removed in the 1950s, but restoration work by current owners includes the original roofline.

Flintlock, a farmhouse located on Lawrence Road, is situated on land purchased by Henry Lawrence in 1710. His father, David Lawrence of Pembrokshire, Wales, was one of the earliest settlers in Haverford Township. The original house was a stone-ender like the Lawrence Cabin now in Powder Mill Valley. The springhouse, visible from the road today, was included in the 1798 Direct Tax, and a springhouse was listed earlier in Henry's will, dated 1762. Many early features remain in this Welsh Tract home.

Eight

NEIGHBORHOODS

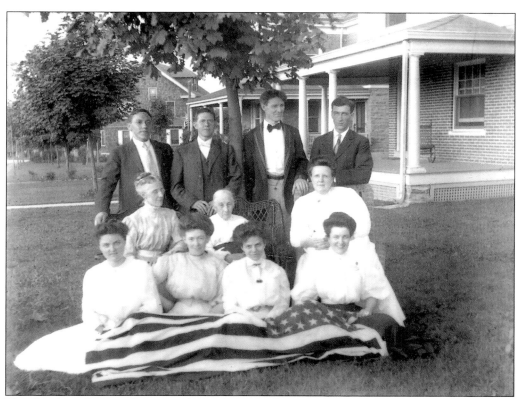

This family gathers in the spirit of patriotism on this Decoration Day in Llanerch. In the early part of the 20th century, Memorial Day was a more widely honored holiday than the Fourth of July. The matriarch, with the flag covering her lap, is encircled by her family as they pose on the lawn of their home on Tenby Road for Wilbur Hall's camera.

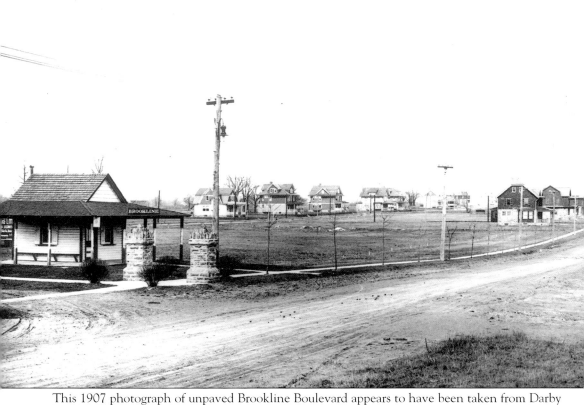

This 1907 photograph of unpaved Brookline Boulevard appears to have been taken from Darby Road before the trolley tracks were installed. The Ardmore trolley line was opened in 1912. The historical society was very fortunate to receive a collection of photographs taken years ago for Watts Real Estate. Barbara Morris, granddaughter of real-estate agent J. Elmer Watts, donated

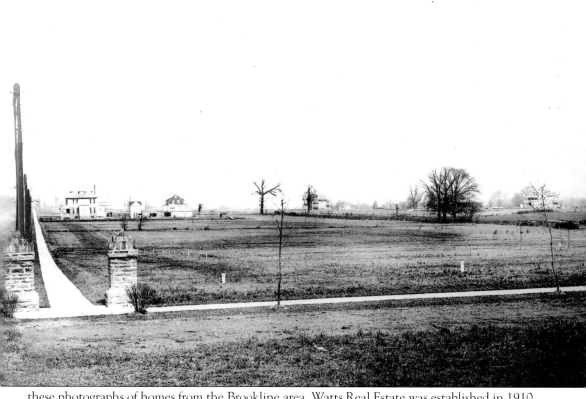

these photographs of homes from the Brookline area. Watts Real Estate was established in 1910, and many of the pictures show homes in varying stages of construction. It is quite amazing to see how open this part of the township was at the beginning of the 20th century.

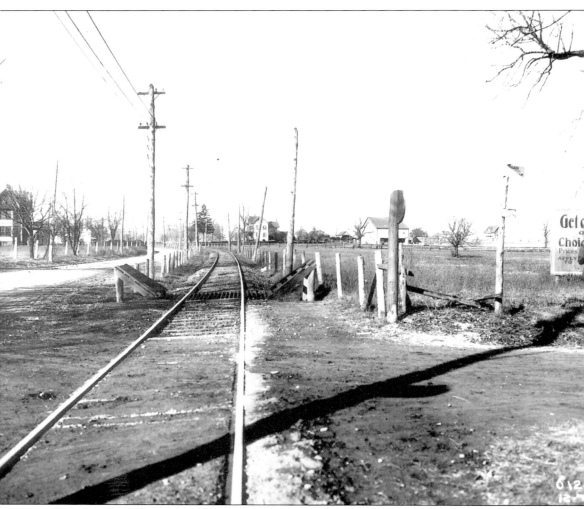

This 1911 barren, northbound view of the Pennington Farm on Darby Road at Mill Road is now occupied by the Haverford Township Free Library and the Haverford Middle School. The gentleman is standing in front of a sign enticing trolley travelers to buy "choice building lots." The trolley tracks, wooden stop sign, and cow guards are long gone. Mill Road is now home to the Haverford Senior High School and Woodmere Park homes.

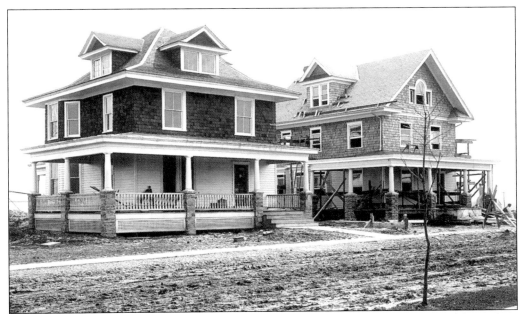

Under construction at 427 Kathmere Road is a home that will be occupied by one of the earliest residents of the Brookline community. Built c. 1910, the house would see many owners, among them Dr. Charles Ware, first pastor of Temple Lutheran Church. After Dr. Ware's resignation, the church bought the house in 1920 as a parsonage for their second pastor, Dr. William Ney.

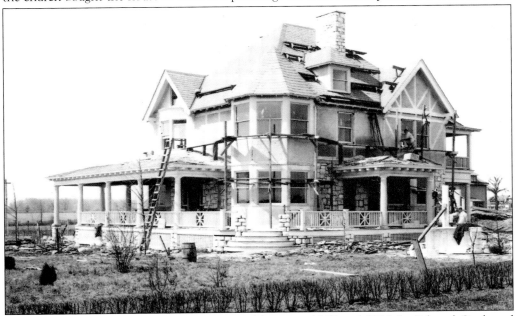

This country estate was built on Manoa Road between 1907 and 1910 for Edward Cook and later became the Jaworski residence. It is interesting to see the methods of construction back then. Even the scaffolding and the ladder look like they are hand made. The cleanup after this project must have been enormous. Another view of this eclectic home under construction can be glimpsed in the photograph on page 107.

Charles Washington Gettz, the family patriarch, poses with his wife, Sara, grandson William, and their cast-iron dog in front of their Manoa home. According to Reverend Fritsch, longtime pastor of Trinity Lutheran Church, stops on the trolley line coming out of Philadelphia were Llanerch, Lower Gettz, Upper Gettz, and Trinity Lutheran Church.

Herbert W. Gettz, charter member and pillar of Trinity Lutheran Church, is seen here on his farm in Manoa c. 1900. He was the son of Charles Gettz, who donated the land for the church. Outliving two wives and without children, Herbert spent his later years in the home of his sister Lillian Huges, wife of Thomas Huges, also a Trinity Lutheran Church charter member.

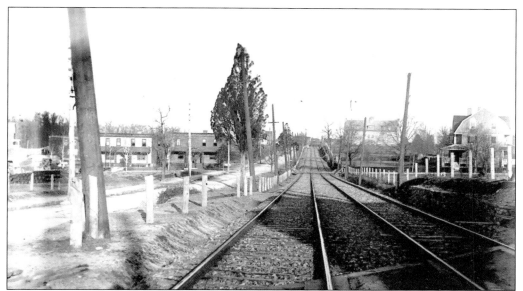

Looking north on Darby Road along the tracks of the Ardmore line, the Llanerch School is visible at the top of the hill in this Wilbur Hall photograph. The twin home in the right middle ground is still at the corner of Park Road today. A coal yard existed to the far left of the tracks where Burger King is today.

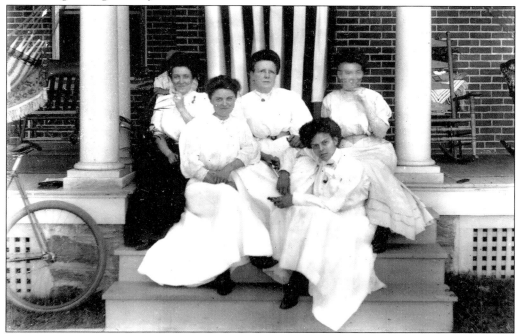

Perhaps these pretty ladies in their shirtdresses are gathered on the front porch steps to watch a parade in the early 1900s. The flag hangs as a backdrop for these Wilbur Hall subjects. Most civic associations and fire companies still celebrate patriotic holidays with a neighborhood parade. Unlike homes of today, this porch is loaded down with rockers, a bench, and a couple of hammocks.

Here, Wilbur Hall's studio awaits his next portrait sitter. The sentimental portrait on the wall is signed "Our Father." With a magnifying glass, you may be able to make out that the one wall hanging is actually a collection or collage of photographs. It is rare to find these interior shots. Taking a flash photograph meant using highly combustible materials, a dangerous endeavor indoors.

Wilbur Hall photographed this proud couple in their home in Haverford Township. Interior pictures like this provide wonderful clues about heating, furniture styles, and household items at the turn of the century. The sideboard behind the gentleman seems to be groaning under the weight of all the silver and glassware displayed on it.

At the turn of the century, the Philadelphia and Western line was a leading force for the growth of housing developments. This fanciful brochure for the Beechwood community in 1908 points out the convenience of the area to the city, as well as the attraction of the Beechwood Amusement Park at the Beechwood Philadelphia and Western station. The park, which opened in 1907 and closed in 1909, was built to entice travelers from Philadelphia to use the Philadelphia and Western line. (Courtesy of the Roger T. Prichard Collection.)

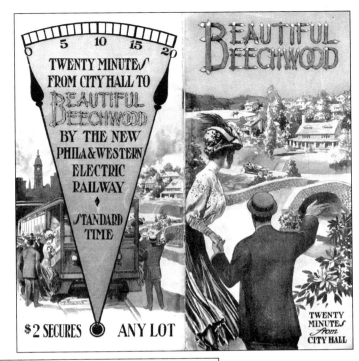

FREE CAR FARE
FOR ONE YEAR

TO the head of each family purchasing, building, and residing at BEECHWOOD before September 1st, 1908, we will give one year's car fare free. This guarantee covers one fare a day (each way) to Philadelphia for a year. Meanwhile, and for all time, you can go to BEECHWOOD for less money than you can travel by steam lines for any corresponding distance.

BEECHWOOD ENVIRONS

Improvements

WE are improving BEECHWOOD in a high-class substantial manner. No expense will be spared in making it one of the most attractive Philadelphia properties we have ever placed upon the market. A large number of workmen are now laying superior cement walks, streets are being graded and in fact the property is being rapidly transformed into a high-class residential section. Gas and electric light service will also be introduced, as soon as satisfactory arrangements can be made. And, remember, these improvements are put in at *our expense* and do not cost the purchaser a single penny.

FREE INSURANCE WITH
EVERY PURCHASE

THE buyer of any lot at BEECHWOOD is insured, in case of death one year subsequent to his purchase, to the full value of the lot, provided he was under 60 years of age and in good health at the time of purchase, and provided also that he has never been more than 30 days in arrears in his payments. And should the purchaser die within one year of his first payment, we will pay back all his money with six per cent interest.

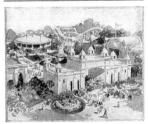

BEECHWOOD PARK

How to get to Beechwood

TAKE the Subway and Elevated Cars on Market Street to 69th Street Station; thence direct, in five minutes, to BEECHWOOD, on the Philadelphia and Western Electric Road. Our agents are on the grounds week days and Sundays and will refund carfare to all customers.

How to Drive to Beechwood

Taking City Line Road at Overbrook as a starting point, drive south to Haverford Road and then west about a mile to BEECHWOOD, which lies on the left.

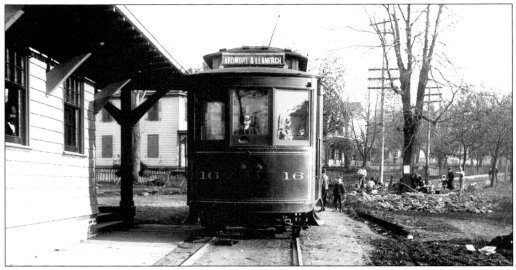

The Ardmore and Llanerch trolley No. 16 rolls into the station while construction workers clear stone and brush for the new roadway along the tracks. In the background, a worker guides a mother and child through the construction site toward the station. Buses replaced trolley service in the late 1960s.

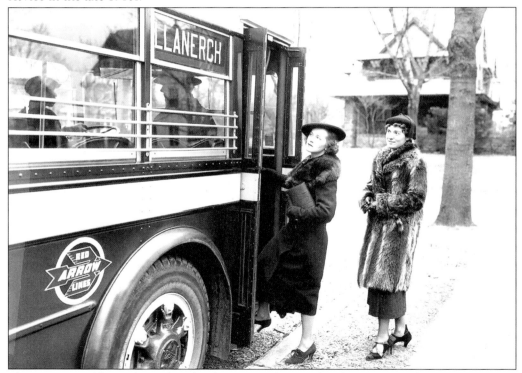

This *c.* 1940 publicity shot taken for the new Red Arrow bus line was posed at Davis and Park Roads. This was never an actual stop on the bus route that ran from the Sixty-ninth Street Terminal, out West Chester Pike, and onto Darby Road. (Courtesy of the Hagley Museum and Library.)

Nine

PUBLIC SERVICE, CIVIC PRIDE

Bob Fox's 1960 photograph shows Memorial Day ceremonies being held next to Oakmont's firehouse. This photograph is a testament to the pride and dedication all our volunteer fire companies share in Haverford Township. In preparing this book, it has been a real pleasure getting to meet some of these courageous and selfless heroes. Many thanks are extended to them.

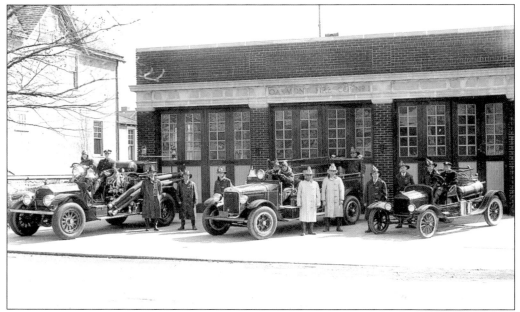

The volunteers of the Oakmont Fire Company No. 1 pose next to their state-of-the-art firefighting equipment and new, permanent home in this 1929 photograph. Organized in 1914, Oakmont's fire company was originally housed in Little's Garage, where Peabody's Pub stands today on Darby Road. Firefighting apparatus and cars, parked for a monthly fee, took up space up front, while the back room of the garage was set up as a movie house.

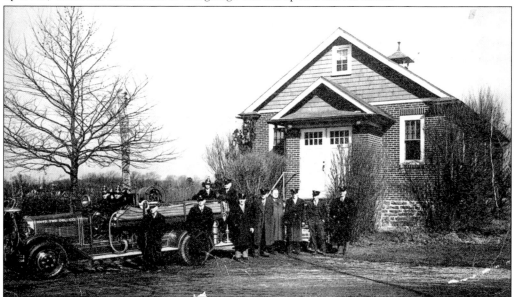

The volunteer firemen of Bon Air stand next to their fire truck and in front of their building on Royal Avenue in this photograph taken between 1932 and 1939. Like other organizations, this fire company shared its facilities with other groups until expansion was necessary, or when funds became available. Organized in 1918, the fire company was originally known as the Bon Air Fire and Civic Association.

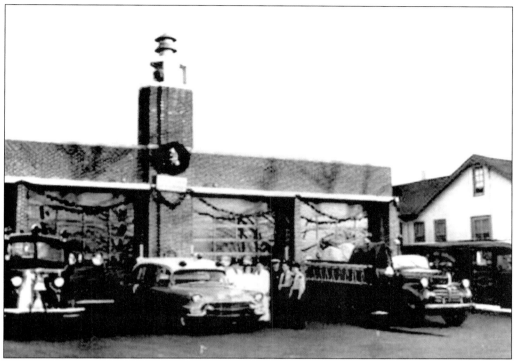

Perhaps used for a Christmas card or just to show off the new ambulance, this photograph shows the firefighters and ambulance corps of the Manoa Fire Station. The new firehouse, located just below West Chester Pike on Eagle Road, was erected in 1952–1953 to allow for the larger firefighting apparatus. Organized in 1925, the Manoa Fire Company was originally known as the Eagle Precinct Fire Association.

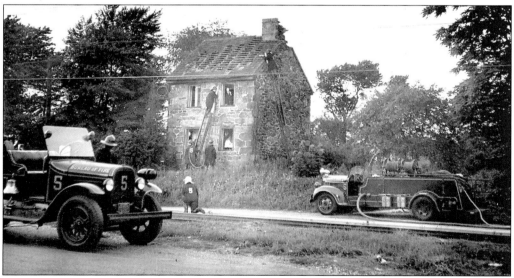

After years of neglect, Toll House No. 4, on West Chester Pike, served the community one last time when the Manoa Fire Company got permission to use it for a practice drill. The building was deliberately set on fire, and the firefighters put their equipment and talent to the test.

In Llanerch, Pa.

This vintage postcard shows the original building that would later house the Llanerch Fire Company. It was built in conjunction with the development of the Llanerch section of Haverford Township. Later, Grafstrom's Drug Store was enlarged and converted into a grocery store before its next transformation. The building, though recently remodeled, retains its unique roofline. (Courtesy of the Keith Lockhart Historical Collection.)

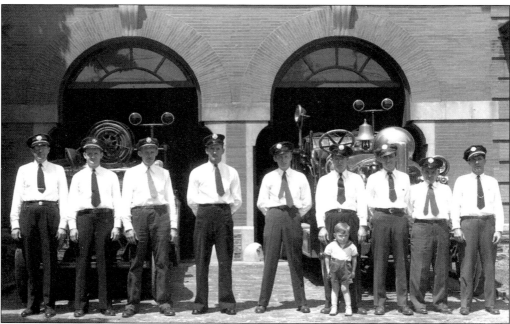

Llanerch Fire Company No. 2 volunteers pose for this 1946 Memorial Day photograph. It is interesting to note that the 1923 Ahrens-Fox pumper is still in use. According to the January 1940 committee minutes (handwritten by secretary-treasurer Leonard Levi, standing in the middle), the newly elected officers moved to form a committee to amend the bylaws and explore means of building up the treasury. It certainly takes a lot of time and money to replace firefighting equipment.

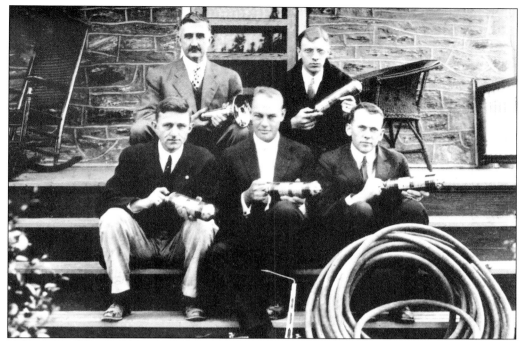

Volunteers of the Brookline Fire Company sit on the steps of their first meeting place, a private residence. From left to right are the following: (front row) J.R. Lloyd, J.H. Pelley, and Edward Bryant; (back row) Tom Weidemann and R.M. Hirst. Four of the five men are posing with state-of-the-art hand extinguishers. Tom Weidemann is holding a speaking trumpet for calling out commands.

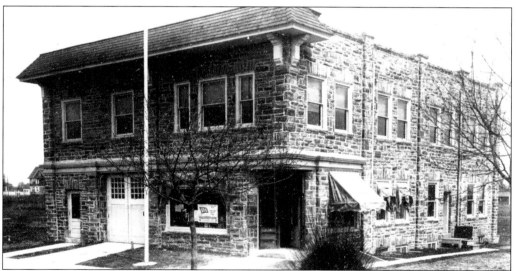

It was a tight fit for the Brookline Fire Company's spider, a hand-pulled hose cart, to get through the narrow garage doors on the left. This postcard shows the early configuration of the Brookline Fire House and McGill's Butcher Shop. Notice that the lot to the left of the building is open space. The Victoria Arms Apartments, which remains as the township's tallest building, has not been built yet. (Courtesy of the Keith Lockhart Historical Collection.)

This little fellow proudly poses on the fender of an Ahrens-Fox pump and hose fire truck while clutching the trophy Llanerch Fire Company won that day in 1923. All five of our community's volunteer fire companies have provided invaluable service over the years. They are the backbone of our township's response to emergencies and disasters. We need to recognize the sacrifices they and their families make to help us in our time of need.

This Haverford Township police officer and his two young companions lead off the Memorial Day parade as it makes its way down from Oakmont Elementary School. The undated photograph looks like it was taken in the late 1930 or early 1940s, judging from the automobiles behind the trolley stop.

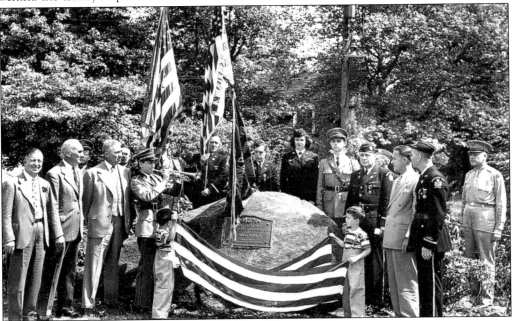

This photograph exemplifies the community pride displayed by the residents of the Penfield section of Haverford Township. The Memorial Day celebration of 1947 got under way with the dedication of the new World War II memorial, still standing at Manoa Road and Karakung Drive. The Penfield Civic Association also cut the ribbon on the new Powder Mill Park and Grange Playfield.

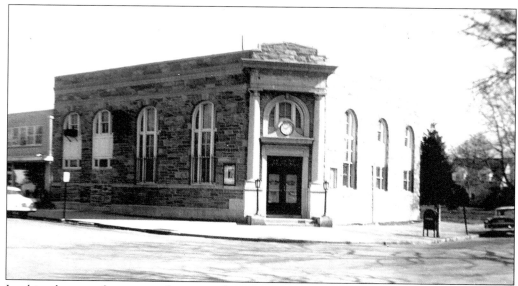

In this photograph, we see the original entrance to the Haverford Township Free Library. Originally built in 1926 to house the Media, Sixty-ninth Street Title and Trust Company, it was abandoned during the Great Depression. H. Gates Lloyd purchased the building and donated it to the township. The library was organized in January 1934 through the efforts of residents and local groups under the leadership of Armand N. Spitz.

The Manoa Public Library got its start in 1935 with donated books and borrowed space in the basement of the Manoa Elementary School. In 1958, school enrollment increased and the library was forced to close. Concerned citizens organized to find a suitable space to house another library. In 1973, the Manoa Library, privately owned and operated by 17 families in Manoa, reopened at the corner of Manoa and Eagle Roads.

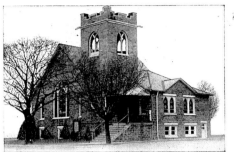

"For God and Our Country"

Frank Murta

IS REPRESENTED BY A STAR
ON THE SERVICE FLAG OF OUR CHURCH
Dedication Service, Sunday, April 4th, 1943

TRINITY EVANGELICAL LUTHERAN CHURCH
WEST CHESTER PIKE, MANOA, PA.

Trinity Evangelical Lutheran Church, pictured on the left of this 1943 certificate of acknowledgment, pays tribute to its 302 congregational members who served in World War II. A blue star on the service flag of the church represented each man or woman serving in the military. If one of them died in the line of duty, their star would be switched to gold.

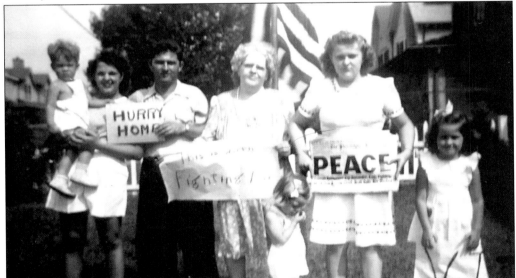

In this photograph, taken around V-J Day (August 15, 1945), family of stateside serviceman Frank C. Murta gather in front of their homes on Waverly Road in Manoa to display their messages. Like many who worked in factories that supplied valuable materials for our troops, the young man shown here was deferred from active military service because of his job at Crucible Steel in Lansdowne, Pennsylvania.

123

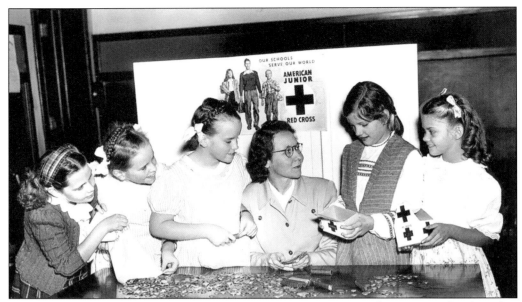

In this 1948 photograph, young ladies work with their Oakmont Elementary School teacher to sort the donations collected for the Red Cross. Similar scenes were repeated throughout the country during the post–World War II era. Everyone, young and old, was enlisted to lend support to humanitarian relief organizations.

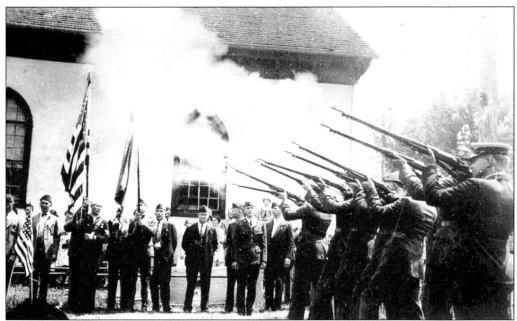

American Legion Post 667 of Manoa honors the war dead at Memorial Day services in 1937. Post members marched from the Post House on Steel Road down to the cemetery at the Old Bethesda Church, located on Manoa Road. This photograph was snapped at the moment rifles were fired to salute the fallen heroes. The Gothic Revival church and hallowed cemetery made a dramatic backdrop for this sacred and somber occasion.

This photograph, taken on Memorial Day 1937, shows the Junior Auxiliary standing on the steps of Manoa Post 667 to model their new marching attire. Esther Schlegel (in the back row on the right), president of the auxiliary, did all the sewing. Back then, in order to qualify for the auxiliary, a woman had to have a father, brother, or husband who was a veteran of one of the wars.

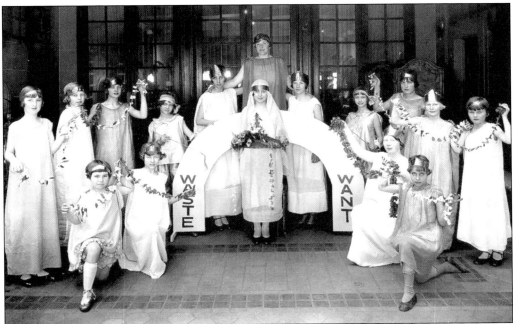

The young ladies of the Bon Air Branch of Needlework Guild pose in this undated photograph in front of the Philadelphia's Bellevue Strafford Hotel. At the time of the 1935 *Haverford Township Business and Professional Directory*, there were five Needlework Guilds in our community. These groups were established to teach and maintain the traditions of fine needlework. Often the sewing projects were distributed to the needy.

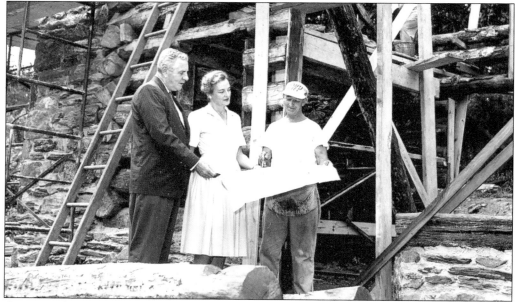

Committed to protecting our community's heritage, the Haverford Township Historical Society, under the leadership of Peg Johnston, set to work to save this log cabin. Built along the banks of Darby Creek *c.* 1710, the cabin was slated for demolition. After considerable deliberation, fundraising, and red tape, the cabin was meticulously dismantled and reerected next to another historic landmark, Nitre Hall, situated on the picturesque Karakung Drive.

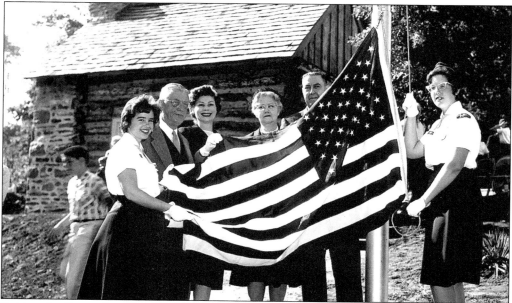

Raising the flag at the dedication of the reconstructed Lawrence Cabin is a fitting tribute to the pride and dedication shown by our community. Photographer Bob Fox could not have known that when he shot this photograph, he would be capturing the smile of a future Haverford Township Historical Society board member, Girl Scout Irene Donnelly Coffey, standing on the far left.

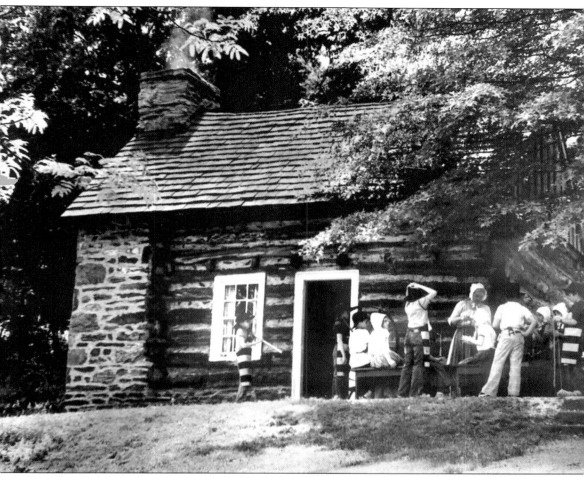

Here is one last look at Lawrence Cabin in this photograph by Richard Finelli. This image truly represents that which our organization is all about—the passing down of our community's history from one generation to another. The Colonial Living Program continues to provide our children with the opportunity to experience life as it might have been for our Welsh Quaker forefathers when they settled here in Haverford Township.

ACKNOWLEDGMENTS

The Haverford Township Historical Society is deeply indebted to the tireless efforts of the Book Committee, especially chairwoman Susan Facciolli and members Betty Murta Graham, Donna Lunny, Renee Silver DeFiore, Mary Courtney, and Carolyn Joseph. Without their hard work and dedication, this publication would not have been possible. A special word of thanks goes to Renee Silver DeFiore for the many hours she spent organizing and cross-referencing the historical society's research files long before this book was ever planned.

We wish to thank the following people and organizations for their help providing us with images, research material, as well as technical and moral support: Adeline Ciannella, director of Haverford Township Free Library; Tom Smith, archivist of Seller's Memorial Free Library; Barbara Hall, curator of Photograph Archives Hagley Museum; Keith Lockhart, Keith Lockhart Historical Collection; Eric Greenberg, Philadelphia Jewish Archives Center; Pam Powell, Chester County Historical Society; Rich Paul, Thomas Massey House; Robert Young, principal Oakmont Elementary School; Marybeth Lauer, Community Relations School District of Haverford Township; Donna Lunny, Temple Lutheran Church; Bob Hamilton, St. George Episcopal Church; George Flickenger, Llanerch Presbyterian Church; Lorayne Currie, St. Denis Roman Catholic Church; Lou Lattanzio and Chief Michael Norman, Manoa Fire Company; Chief Norman, Oakmont Fire Company; Sam Berry, Bon Air Fire Company; Chris Millay, Llanerch Fire Company; Chief John Viola, Brookline Fire Company; Dan Comly, George Christ and Robert Barksdale, Llanerch Country Club; John Capers, Merion Golf Course; Arthur and Graham Wagner, Coldwell Banker Real Estate; Susan Greenspon, News of Delaware County; Robert Calhoun; Renee Coffey; Mae England; Robert Fox; Betty Murta Graham; Peggy Schlegel Hoffman; Benjamin Jaworski; Betty Hammett Lipton; Roger T. Prichard; Mark Rupp; August Schimkaitis, photographer; Anita Intenzo, technical and moral support; and Michael Facciolli, technical support and godsend.